Whistler

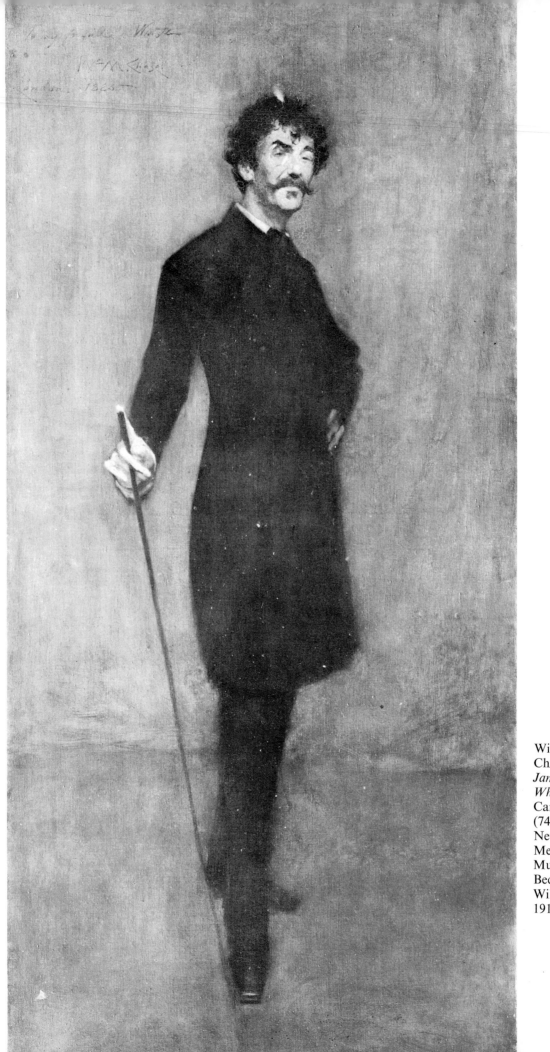

William Merritt
Chase (1849–1916):
*James A. McNeill
Whistler*. 1885.
Canvas, 189×92 cm.
(74$\frac{3}{8}$ × 36$\frac{1}{4}$ in.)
New York,
Metropolitan
Museum of Art,
Bequest of
William H. Walker,
1918

Whistler

Frances Spalding

Phaidon · Oxford

Acknowledgements

I am indebted to the University Court, Glasgow University, for permission to quote from Whistler's letters to his wife; to the Maryland Institute, College of Art, for the use of a letter from Whistler to George A. Lucas in their Lucas Collection; and to the Library of Congress, Washington, D.C., for the use of a letter from Whistler to F. R. Leyland in their Pennell-Whistler Collection. My thanks go also to Martin Hopkinson, Jack Baldwin and Margaret F. MacDonald for their help and encouragement.

Plates 18, 20, 32, 34, 47, 56, 62, 63 and 67 are published by courtesy of the Smithsonian Institute, Freer Gallery of Art, Washington D.C. The works reproduced in Plates 33, 50, 51, 54, 55, 60, 65, 70 and 71 are part of the Birnie Philip Bequest, Hunterian Art Gallery, University of Glasgow.

For my sleeping partner

Phaidon Press Limited, Littlegate House,
St Ebbe's Street, Oxford

First published 1979
Published in the United States of America
by E. P. Dutton, New York
© 1979 Phaidon Press Limited
All rights reserved

ISBN 0 7148 1972 7
Library of Congress Catalog Card Number: 78-73433

Printed in Great Britain by Waterlow (Dunstable) Ltd

4

List of Plates

Select Bibliography

Unless otherwise stated all books were published in London.

BARBIER, Carl Paul (ed.), *Correspondance: Mallarmé-Whistler. Histoire de la Grande Amitié de leurs dernières années.* Paris: Nizet, 1964

COLUMBIA University, *From Realism to Symbolism: Whistler and His World.* Catalogue to exhibition shown at Wildenstein's, New York, and Philadelphia Museum of Art, 1971

DEMPSEY, Andrew, 'Whistler and Sickert: A Friendship at its End,' *Apollo*, LXXXIII, 1966, pp. 30–7

DURET, Théodore, *Whistler.* Grant Richards, 1917 (English translation by Frank Rutter of 1904 French edition)

EDDY, Arthur Jerome, *Recollections and Impressions of James Abbott McNeill Whistler.* Lippincott, 1903

FERRIDAY, Peter, 'The Peacock Room,' *Architectural Review*, CXXV, 1959, pp. 407–14

FLEMING, Gordon, *The Young Whistler.* Allen and Unwin, 1978

GAUNT, William, *The Aesthetic Adventure.* Cape, 1945

GAUNT, William, *Chelsea.* Batsford, 1954

GREGORY, Horace, *The World of James McNeill Whistler.* Hutchinson, 1961

GRIEVE, Alistair, 'Whistler and the Pre-Raphaelites,' *Art Quarterly*, XXXIV, 1971, pp. 219–28

HOLDEN, Donald, *Whistler Landscapes and Seascapes.* New York: Watson Guptill, 1969

KENNEDY, Edward G., *The Etched Work of Whistler.* New York: The Grolier Club, 1910

LAVER, James, *Whistler.* Faber & Faber, 1930 (Revised edition 1951)

LEVY, Mervyn, *Whistler Lithographs. An Illustrated Catalogue Raisonné.* Jupiter, 1975

MACDONALD, Margaret F., 'Whistler: The Painting of the 'Mother', *Gazette des Beaux-Arts*, LXXXV, 1975, pp. 73–88

MACDONALD, Margaret F., *Whistler. The Graphic Work: Amsterdam, Liverpool, London, Venice.* Catalogue to exhibition held at Agnew's, London, the Walker Art Gallery, Liverpool, and the Hunterian Art Gallery, University of Glasgow, 1976

MACINNES, M. F., 'Whistler's Last Years: Spring 1901—Algiers and Corsica,' *Gazette des Beaux-Arts*, LXXIII, 1969, pp. 323–42

MAHEY, J. A., 'The Letters of James McNeill Whistler to George A. Lucas,' *Art Bulletin*, XLIX, 1967, pp. 247–57

MANSFIELD, Howard, *A Descriptive Catalogue of the Etchings and Drypoints of James Abbott Whistler.* Chicago: The Caxton Club, 1909

McMULLEN, Roy, *Victorian Outsider*, Macmillan, 1974

MENPES, Mortimer, *Whistler as I Knew Him.* Adam & Charles Black, 1904

MUNHALL, Edgar, 'Whistler's Portrait of Robert de Montesquiou,' *Gazette des Beaux-Arts*, LXXI, 1968, pp. 231–42

PEARSON, Hesketh, *The Man Whistler.* Methuen, 1952

PENNELL, E. R. & J., *The Life of James McNeill Whistler* (2 vols). William Heinemann, 1908

PENNELL, E. R., *The Whistler Journal.* Philadelphia: Lippincott, 1921

PEVSNER, Nikolaus, 'Whistler's "Valparaiso Harbour" at the Tate Gallery,' *Burlington Magazine*, LXXIX, 1941, pp. 115–20

PRESSLY, Nancy Dorfman, 'Whistler in America: An Album of Early Drawings,' *Metropolitan Museum Journal*, V, 1972, pp. 125–54

PRIDEAUX, Tom, *The World of Whistler 1834–1903.* New York: Time Life Books, 1970

ROBERTSON, Graham, *Time Was.* Hamish Hamilton, 1931

RUTTER, Frank, *James McNeill Whistler. An Estimate and Biography.* Grant Richards, 1911

SANDBERG, John, ' "Japonisme" and Whistler,' *Burlington Magazine*, CVI, 1964, pp. 500–7

SANDBERG, John, 'Whistler Studies,' *Art Bulletin*, L, 1968, pp. 59–64

SICKERT, Bernard, *Whistler.* Duckworth, 1908

SICKERT, Walter, *A Free House! or the Artist as Craftsman: Being the Writings of Walter Richard Sickert.* Macmillan, 1947

SUTTON, Denys, *Nocturne: The Art of James McNeill Whistler.* Country Life, 1963

SUTTON, Denys, *James McNeill Whistler. Paintings, Etchings, Pastels and Watercolours.* Phaidon, 1966

SWEET, Frederick A., *James McNeill Whistler.* Catalogue to exhibition held at the Art Institute of Chicago and the Menson-Williams-Proctor Institute, Utica, 1968

SYMONS, Arthur, *Studies in Seven Arts.* Constable, 1906

TAYLOR, Hilary, *James McNeill Whistler.* Studio Vista, 1978

WAY, T. R. and G. R. Dennis, *The Art of James McNeill Whistler: An Appreciation.* Bell & Sons, 1904

WEINTRAUB, Stanley, *Whistler: A Biography.* Collins, 1974

WHISTLER, James McNeill, *The Gentle Art of Making Enemies.* William Heinemann, 1890

YOUNG, Andrew McLaren, *James McNeill Whistler.* Catalogue to exhibition, 1960

Whistler

Whistler's position in the history of British art is as paradoxical as his personality: flamboyant dandy and ebullient publicist, he was also a serious craftsman dedicated to the perfection of his art; having absorbed influences from his French and English contemporaries, he emerged as an isolated master who attracted a number of followers but established no leading style. Yet the extent of his influence can be gauged by the late and rather shame-faced arrival of French Impressionism in England; Whistler's dominant emphasis on tone militated against it and he deprecated their 'screaming blues and violets and greens'. Proud and independent, his refined sensibility is reflected in even his smallest oil-sketch or pen and ink drawing. His high and often unattainable standard of perfection imposed severe strains on his person, as Henry James observed: 'You have done more of the exquisite, not to have earned more despair, than anything else.' This search for perfection was not an end in itself, but had for Whistler some ulterior spiritual significance; once, after attending a dispiriting musical evening, he turned to his companion, the artist Mortimer Menpes, and said: 'Let us cleanse ourselves, Menpes. Let us print an etching.'

A similar refined taste governed Whistler's appearance. His smartly tailored black frock-coats and jackets, white trousers and white waistcoats at first gave his devoted biographers, Elizabeth and Joseph Pennell, the impression of an old-fashioned American bartender. Small (he was only five foot five) and soigné, to Menpes he always appeared 'dainty and sparkling'. On entering his hairdresser in Regent Street, he immediately became the focus of attention: he directed the cutting of each lock, then dipped his head in a basin of water, wrapped his white forelock in a towel, shaking the rest of his black hair loose in natural curls. Once dry, a loud scream would announce his need for a comb and, after the white forelock had been trained upwards like a feather, he would beam in the mirror, announce 'Menpes, amazing!' and seizing his top hat and cane would leave the shop, spruce, resilient, the dandy and renowned wit.

This extrovert image and his willingness to engage in lawsuits and warfare in the press made Whistler a legend in his own lifetime: facts became merged with fiction; the forces which motivated him as an artist became hidden behind a carefully cultivated, aggressive façade. He referred to himself as 'the butterfly' and used this motif derived from his monogram as his signature; but in his letters to his wife he was also 'the grinder', the craftsman obsessed, like his hero Velasquez, with the single-minded pursuit of an idea, the perfection of his art. Although his art is the product of taste, the discovery of the charming and the beautiful rather than the profound, he abhorred smart handling, slick-

ness and superficiality and would repeatedly rub down his canvases and begin again. In conversation with the Pennells, he described the Venetian painters' secret, not in terms of technique but in terms of commitment: 'It is being able to go on, go on each day building up and hammering more and more into your work just as the coppersmith works out by degrees his beautiful shapes and surfaces.' He himself was incapable of rest, driven by doubts to persistent reworking of his pictures. His total *oeuvre* is not large, yet it contains a number of masterpieces in which he would have said the 'spirit of the wonderful' appears, the lamp having been rubbed sufficiently to bring out the genie, the grinder being merely the agent in the process.

James McNeill Whistler's career as a painter began when he came of age in 1855 and went to Paris. Certain background factors, however, have direct relevance to his development as an artist. His father was a major and a resourceful railroad engineer, whose career ensured for the young James a cosmopolitan background. Born in Lowell, Massachusetts, in 1834, he spent short spells at Stonington, Connecticut, and Springfield, Massachusetts, and later moved with his family to St Petersburg, where Major Whistler was employed on the building of the St Petersburg to Moscow railroad. The artist's mother, Anna Mathilda McNeill, was a devout Christian who endeavoured to instil her pietistic beliefs in her children and whose abhorrence of ostentation left a marked effect on her son's taste. His admiration for her is indicated by his decision in early manhood to exchange his middle name 'Abbott' for her maiden name 'McNeill'.

A military and engineering background did not prevent Whistler's father from being sympathetic to the arts. In the evenings his half-sister Deborah (one of three children from Major Whistler's previous marriage) would play the harp or piano, or would sing. Major Whistler, on a holiday visit to England, commissioned a portrait of James from the artist William Boxall and in Russia showed a general interest in the culture around him by visiting the imperial palaces and museums. The young Whistler accompanied his parents to, among others, the palace built by Catherine the Great at Tsarkoe Selo, which had a room decorated in the Chinese style. He would almost certainly have been taken to the Hermitage (though his mother's diary makes no reference to such a trip). One gallery there was devoted to the night scenes by the Dutch painter Aert van der Neer, who concentrated on effects of moonlight on water. But perhaps more memorable for the young boy living on the English Quay, which directly overlooked the River Neva, were the frequent nocturnal firework displays that lit up the darkness with sudden showers of gold, a motif later to reappear in his 'Nocturnes'.

As a child Whistler had a passion for drawing. After a visit from the Scottish genre painter Sir William Allan, who admired the young boy's work, he was sent three times a week to the Imperial Academy of Fine Arts, where, in keeping with the academic tradition of art teaching, he drew from plaster casts of antique sculpture. A sketch-book from this period (now at the University of Glasgow) shows that he was also copying religious and historical paintings. In 1846 his mother took him on more than one occasion to the Tri-ennial Exhibition of the Academy in order to familiarize him with contemporary artists, retaining, however, her hope that his ultimate career would be that of an architect or engineer.

While living in St Petersburg the family made two visits to England. On the first, Deborah married the English surgeon, Francis Seymour Haden, who had earlier learnt etching techniques for the purpose of making

anatomical drawings and whose interest in this medium was to be reawakened by his brother-in-law in the late fifties. The Hadens' house in Sloane Street provided the Whistler family with a base in England and on their second visit the young Whistler was left behind to complete his education, first at Portishead, near Bristol, and then in London. In 1849 Major Whistler died and his wife decided to return with her family to their homeland, settling at Pomfret, Connecticut, where James attended the local school until, in 1851, he was selected to go to West Point, the famous military academy on the west bank of the Hudson River and accessible only by boat.

West Point was not only isolated from society by its geographical position but also by its exclusiveness. Cadets were selected by congressmen and came mainly from distinguished families or from the southern aristocracy. Whistler's father had trained at West Point and this no doubt secured his entry. He was delighted to find himself 'very dandy in grey' and his years there were notable as much for his social success as for his dismal performance at all things military. The art master Robert W. Weir encouraged his skill at drawing, while his wit compensated for his unskilled horsemanship. The officers at the academy were cordial, distinguished and elegant, and they set a standard of behaviour which Whistler never forgot. Neither a soldier nor an engineer, Whistler nevertheless looked back on his three years at West Point with affection. The reason for his abrupt ejection from this institution was an abysmal failure in chemistry. 'Had silicon been a gas,' he later declared, 'I would have been a major-general.'

West Point was followed by a brief period of employment in the United States Geodetic and Coast Survey offices in Washington. Accounts of this period suggest that Whistler's social life in Washington was not conducive to the keeping of office hours. Not until he entered the etching department did he become absorbed in his work, as a contemporary of his recalled:

For the first time since his entrance into the office, Whistler was intensely interested. . . . He seemed to realise that a new medium for the expression of his artistic sense was being put within his grasp. He listened attentively to McCoy's somewhat wordy explanation, asked a few questions, and squinted inquisitively through his half-closed eyes at the samples of work placed before him.

Whistler then began to work on a topographical view and within a couple of days had produced his first etching (Plate 2). At intervals he broke away from the scientific precision needed for accurate topography and, in styles indebted to the illustrators of *Punch* and the *Illustrated London News*, sketched in the sky heads of characters drawn from his reading of Dickens, Scott, Dumas, Hugo and Thackeray.

Whistler's reading at this date was extensive (he later abandoned the habit and picked it up again only in old age) and among the authors he favoured was Henry Murger, who in 1851 had published *Scènes de la Bohème* (later lengthened and entitled *Scènes de la Vie de Bohème*). Whistler, who had learnt French in St Petersburg, was so familiar with the tales in this book, he is said by the Pennells to have known passages of it by heart. The story centres on four young men, a painter, a writer, a painter-musician and a philosopher, who, convinced of their talents, regard themselves as an élite, outside the conventions and morality that bind normal society. They dress as they please, enjoy the company of *grisettes*, despise discipline and cultivate a deliberate flippancy and language of their own. All these characteristics were already beginning to emerge in the young Whistler. This behaviour

2. *The Coast Survey.* 1854–5. Etching, 14.3 × 26 cm. (5⅝ × 10¼ in.) London, British Museum

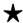

is regarded by Murger as evidence of artistic ability, and a poverty-stricken but gay life-style as a necessary stage in the life of an artist. Murger's tales had first appeared in the magazine *Corsaire*, and when they were published in book form he felt it necessary to add an introduction arguing the respectability of Bohemianism; it is not, he says, peculiar to the present age but a stage through which many famous names (including Homer, Villon, Shakespeare and Molière) have passed. Though the book lacks greatness (its sentimentality partly explains its success), it provided Whistler with a personal morality. Murger advocated 'A life of patience, of courage, in which one cannot fight unless clad in a strong armour of indifference impervious to the attacks of fools and the envious, in which one must not, if one would not stumble on the road, quit for a single moment that pride in oneself which serves as a leaning staff; a charming and terrible life, which has its conquerors and its martyrs, and

on which one should not enter save in resigning oneself in advance to submit to the pitiless law *vae victis*.' Warned of his subsequent isolation and attracted by the suggestion of separateness, similar in spirit but different in form from the social distinction of West Point, Whistler set out to follow Murger's ideal. Geographical direction had been given earlier in the introduction. 'We will add', wrote Murger (contradicting his claim that Bohemians had flourished in ancient Greece and Elizabethan England), 'that Bohemia only exists and is only possible in Paris.'

★

Whistler arrived in the artistic capital of Europe in 1855, just in time to catch the tail end of the Exposition Universelle which ran from May 15 to November 15 and attracted five million visitors. In the Fine Arts section, though five thousand paintings from twenty-eight countries were on view,

10

the battle of styles, between Classicism and Romanticism, still dominated public attention. Their chief exponents, Ingres and Delacroix, were still sufficiently influential to merit detailed attention in Baudelaire's review of the exhibition, which Whistler may have read in order to gain some understanding of the current artistic situation, and where he would have discovered an unacademic definition of beauty: 'The Beautiful is always strange,' wrote Baudelaire; 'I mean that it always contains a touch of strangeness, of simple, unpremeditated and unconscious strangeness, and that it is this touch of strangeness that gives it its particular quality as Beauty.' Baudelaire's fastidious taste and his belief in the purity of art presage the attitude Whistler was later to adopt, and the artist, who was to suffer much antagonism from the critics, would have fully supported Baudelaire's statement: 'Painting is an evocation, a magical operation . . . and when the evoked character, when the reanimated idea has stood forth and

looked us in the face, we have no right . . . to discuss the magician's formulae of evocation.'

This review and others would have directed attention to Courbet's pavilion, which he had erected at his own expense when the government, having accepted eleven of his paintings in the official exhibition, rejected his *The Artist's Studio* and *Burial at Ornans* (Plate 3). These two masterpieces, monumental both in size and conception, were on view with others of Courbet's paintings in the pavilion. The *Funeral*, with its long flat line of cliff pressing down on the frieze-like row of mourners, would have astonished Whistler—first, by its abrupt, vigorous handling of paint, and, secondly, by its lack of idealization in the portrayal of the figures. Instead of ennobling the figures, Courbet had painted what he saw. His shocking realism had become linked with socialism and was feared and distrusted; but he was too great an artist to be ignored. Baudelaire praised his 'positive solidity' and 'unabashed indelicacy', and Whistler found in

3. Gustave Courbet (1819–77): *The Burial at Ornans*. 1848–50.
Canvas, 318.7 × 665.5 cm. (125½ × 262 in.) Paris, Louvre

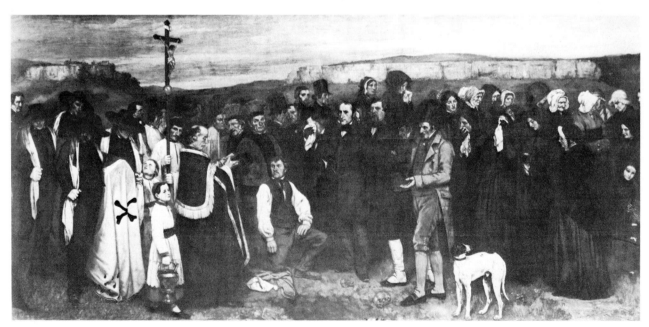

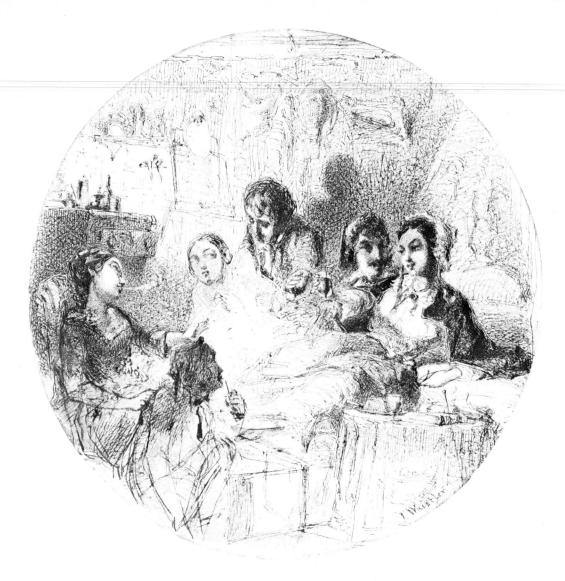

4. *Scene from the Bohemian Life*. About 1857–8.
Pen and ink, diameter 23.8 cm. (9⅜ in.) Chicago, The Art Institute of Chicago, gift of John F. O'Connell

Courbet's attitude to his subjects initial inspiration for his own art. Courbet's aim was to create an art relevant to the age in which he lived and in the manifesto printed in the catalogue to his private show, he declared: 'To be in a position to translate the manners, the ideas, the aspects of my epoch, according to my own estimation; to be not only a painter but a man as well; in a word, to create living art—that has been my aim.'

If, as will be seen, Whistler's early painting took its direction from Courbet, his choice of teacher was surprisingly conventional; after a short period at the École Impériale et Spéciale de Dessin, he enrolled at the studio of Charles-

Gabriel Gleyre, who trained his pupils for the Prix de Rome and other official competitions. He was a morose, uninspiring man, whose greatest success had been a work exhibited at the Salon of 1845, significantly entitled *Lost Illusions*. Gleyre taught his students to make several sketches in quick succession in order to discover the most expressive composition; he taught them to analyse colour relationships and argued that ivory black was the 'universal harmonizer' and the basis of all tones; and finally he taught his students the practice of mixing their colours before starting to paint in order to leave them free to concentrate on drawing. All these lessons

12

were of importance to Whistler. His choice of Gleyre indicates that he already sided with the Classical school, preferring a more restrained palette to the juicy crimsons and peacock blues of the Romantics; but his selection of teacher may also have been determined by the absence of tuition fees and by Gleyre's good reputation.

At Gleyre's, Whistler became part of the 'Paris Gang', a group of young English artists that included Edward Poynter (later President of the Royal Academy), Thomas Armstrong, Thomas Lamont and George Du Maurier. Eager to cultivate a Bohemian life-style, Whistler rapidly spent the quarterly instalments of his annual three hundred and fifty dollar family allowance in imitation of the excesses enjoyed by Murger's heroes and he frequently had to sell his furniture or move into attic lodgings to survive. He was disappointed when his friends did not follow suit: like himself, they all had adequate funds, but chose comfort rather than excess; nor did they share his admiration for Courbet, finding his realism an aberration. Worse still, they insisted on retaining their English customs, undertaking regular physical exercise and dining once a week at an English restaurant, where they ate roast beef and mutton and drank English beer and gin. They, for their part, regarded Whistler with critical amusement: he was the 'King of Bohemia', renowned for his eccentric attire, but he was also the 'Idle Apprentice', criticized by the industrious Poynter for his indolence. In the autumn of 1856 Armstrong found a studio large enough for all five friends to share, but Whistler declined, having found more congenial 'no-shirt' friends, as he called them, among French artists, closer in their life-style to Murger's belief that it is 'rags that make the poet'.

In the public mind, Courbet was the artist most closely associated with Bohemianism;

5. *Head of Old Man Smoking*. About 1858. Canvas, 41 × 33 cm. (16¼ × 13 in.) Paris, Louvre

not only did his art reveal a shocking rejection of the conventional, but he was suspected of having amoral, anti-social beliefs and he frequented the Café Momus, the scene of Murger's café tales. Following Courbet, Whistler's earliest oil-paintings are of the life he saw around him. In Les Halles he observed an old character in a battered hat and offered him forty sous if he would pose. The man agreed, saying that first he must collect his *voiture*, which turned out to be a push-cart full of chamber-pots. He sat for two to three hours and regaled Whistler with songs. The portrait (Plate 5), with its sad, vacant expression, captures his hopeless con-

dition—when Whistler found him he was without a sou. The thick impasto with which it is painted imitates the handling of Courbet's *Funeral at Ornans*. It contrasts notably with Whistler's *Head of a Peasant Woman* (Plate 6), another proletarian subject painted towards the end of his student years in Paris, in which the colours are more restrained and the paintwork is smooth and flat, as if the surface had a 'skin', the quality which Whistler so admired in Dutch seventeenth-century painting. The increase in technical accomplishment would have been encouraged by his trip to Manchester in 1857 to see the Exhibition of Art Treasures which revived interest in the Old Masters and at which there were fourteen paintings then attributed to Velasquez, whom Whistler already regarded as an unsurpassable master.

Early success for Whistler came not, however, through his painting but from his familiarity with the medium of etching. He had arrived in Paris to discover a revival of interest in this medium, instigated by the Barbizon School, who had turned to etching in the 1840s. In 1858 Whistler set out on a walking tour of Alsace-Lorraine and the Rhineland with the painter Ernest Delannoy, and he took with him a set of small copper plates. On these he etched scenes as he went, but when the two friends reached Cologne they ran out of money and the plates had to be left with their landlord in lieu of payment. Once these were returned to Whistler, he had them printed in Paris by Auguste Delâtre under the title *Douze eaux-fortes d'après nature* and dedicated them to his brother-in-law Seymour Haden. Better known as the 'French Set', these etchings, such as *The Kitchen* (Plate 7), though reflecting a debt to seventeenth-century Dutch artists and to Millet, are surprisingly mature. Already they demonstrate Whistler's ability to regard the plate in terms of tone. Their suggestion of

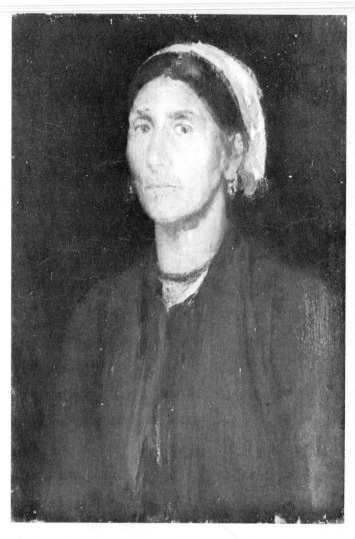

6. *Head of a Peasant Woman*. 1859. Panel, 26 × 18.1 cm. (10¼ × 7⅛ in.) Glasgow, University of Glasgow

7. *The Kitchen*. 1885. Etching, 22.5 × 15.6 cm. (8⅞ × 6⅛ in.) London, British Museum

14

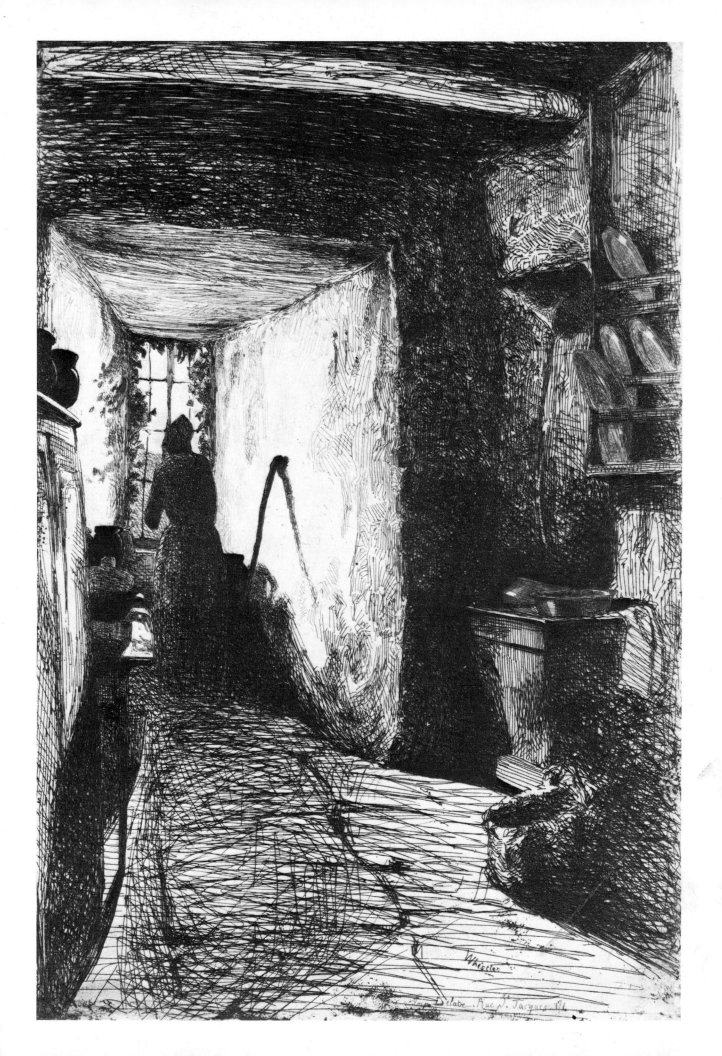

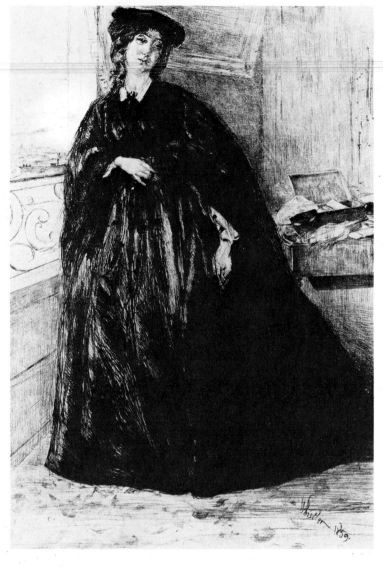

8. *Finette*. 1859. Drypoint, 28.9 × 20 cm. (11⅜ × 7⅞ in.)
London, British Museum

represented the complex grandeur of the city as no artist had done before.

Praise of the 'French Set' encouraged Whistler to continue etching and between 1858 and 1863 he produced eighty plates, a third of which are portraits of friends and relations. In these it is possible to trace the gradual loosening of his technique, as his assurance increased, until his use of the medium comes close to the freedom of pen and ink. Two of the most attractive portraits produced in Paris are those of his mistresses. The first was Fumette (Plate 9), a tempestuous *grisette* who liked to live with men she thought distinguished and who, in a fit of pique, tore up several of Whistler's drawings. After two years of misery, they parted and her place was taken by Finette (Plate 8), an elegant *cocotte*, who later made her way in the English music halls as a professional cancan dancer. Both etchings show Whistler's early preference for standing, full-length portraits and for the suggestion of informality. The second suggests that he had been looking at English illustrations of the period, as the mask and other objects on the table behind indicate that there might be a tale attached to this print.

During these student years in Paris, Whistler spent as much time copying in the Louvre as he did in Gleyre's studio and on one of these visits he fell into conversation with a young French artist, Henri Fantin-Latour. Fantin, who was half-Slav, was short, thick-set, hypersensitive, alternately depressed and high-spirited. He had studied under Lecoq de Boisbaudron and briefly at the École des Beaux-Arts and had earned himself some success as a copyist: he was greatly attracted to Veronese's *Marriage at Cana*, of which he made five copies. But his chief quality as an artist, and one that would have attracted Whistler to him, was his impeccable handling of tonal relationships. The two men struck up

colour, as the critic Théodore Duret noted, makes them 'a painter's etchings' and they have none of the stiffness that the nature of the medium often attracts. Whistler is said to have stood at Delâtre's side while they were printed and his knowledge of the techniques of printmaking would have greatly increased through association with this man, whose shop was a rendezvous for printmakers and who had been responsible for printing, between 1852 and 1854, Charles Meryon's famous *Eaux-Fortes sur Paris*, which had

16

an immediate friendship and that evening Whistler accompanied Fantin to the Café Molière, where he met, among other artists, Alphonse Legros, a precise, grave man with a hooked nose and a carefully trimmed beard. Legros specialized in devotional subjects and church scenes. Like Fantin, he had trained under Lecoq de Boisbaudran and the two men taught Whistler Lecoq's belief that the training of the visual memory freed the artist from slavish imitation of nature. In conversation, the three men discovered their shared

admiration for Courbet and for Dutch and Spanish seventeenth-century painting; Fantin and Legros admired Whistler's 'French Set', which he had brought with him to show them, and before long it was agreed that their sympathies and interests should unite them in a 'Société des Trois'.

Shortly after meeting Fantin, Whistler set to work on his first major painting, which he intended to send to the Salon of 1859. Fantin also determined to make his artistic début at this Salon with his *The Artist's Two Sisters* (Plate 10). As a drawing related to the left-hand figure in this painting (Oxford, Ashmolean Museum) is dated 1857, it seems Fantin arrived first at the idea of two figures in close relationship in an intimate domestic setting; but in the final result it is Whistler's *At the Piano* (Plate 11) that is by far the greater in conception. Both artists placed their figures on opposing sides of the canvas, but in Fantin's the use of diagonals to create compositional movement gives it a see-saw rhythm that is less suited to the contemplative mood than Whistler's strict use of horizontals and verticals. The mood of sadness in Fantin's painting is prophetic of his sister's forthcoming illness; Nathalie's distraction, as she looks away from her sewing, was to turn to mental disorder in 1859 and make her a lifelong inmate of an asylum.

In *At the Piano* a similar mood of quiet concentration is heightened by the choice of subject and the suggestion of listening; the painting becomes the visual counterpart of an individual's inner experience of music. It was begun in the music room of the Hadens' Sloane Street home in the winter of 1858 and completed in Paris early the following year from Whistler's memory of the scene. His winter visit to London was, he thought, of importance to this painting; he may have looked at the Vermeers in the National Gallery as the design of the painting is as

9. *Fumette Standing*. 1859. Drypoint, 34.5 × 21.5 cm. (13⅝ × 8½ in.) London, British Museum

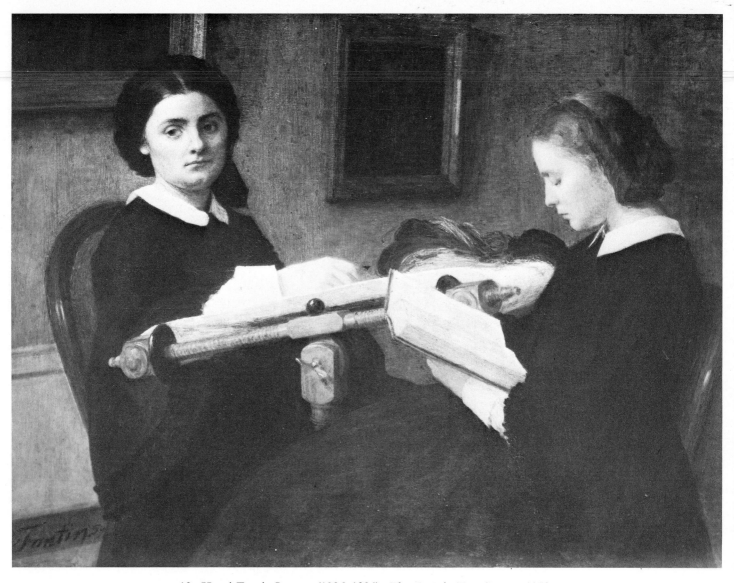

10. Henri Fantin-Latour (1836–1904): *The Artist's Two Sisters*. 1859.
Canvas, 98 × 130 cm. (38⅝ × 51⅛ in.) St. Louis, Art Museum

keenly considered as a Vermeer and similar in mood to the quiet interiors painted by him and by Pieter de Hooch. Whistler's visit seems to have confirmed him in his move away from the clumsy imitation of Courbet's direct handling to a more refined realism, totally devoid of the political implications attached to Courbet's art. The paintwork is still in places heavily impastoed but the handling is more controlled, the tones balanced with such skill that the artist can boldly oppose the black mass of Deborah Haden's dress (reminiscent of Finette's sculptural gown) with the stark

white frock of her daughter.

It seems unlikely that a man who had not responded deeply to music could have painted this subject. Music had been a part of Whistler's childhood and at 62 Sloane Street he continued to listen to his sister play and sing and possibly accompany her husband, whose violoncello case can be seen in the painting beneath the piano along with that of a violin. In Paris, Whistler's friend, the sculptor Becquet, earned his living by playing in an orchestra and Whistler etched his portrait, showing him with the 'cello between

18

11. *At the Piano*. 1858–9. Canvas, 66 × 90 cm. (26 × 35⅜ in.) Cincinnati, Taft Museum

his knees. Later, in London, he enjoyed music at the home of the Greaves, encouraged hurdy-gurdies to play in the garden outside his house, and painted a vivid portrait of the violinist, Sarasate. Aware of a profound correspondence between his artistic aims and his experience of music, he later entitled his paintings 'Symphonies', 'Nocturnes', 'Arrangements' and 'Harmonies' and said of these titles: 'By the names of the pictures . . . I point out something of what I mean in my theory of painting.' With music, the listener responds to the relationship of sounds which,

except in occasional instances, have no representational content. Whistler wanted to create in his art an experience as disinterested and pure as that offered by music. The compositional severity of *At the Piano* marks the first step in this direction; figures and objects are placed in one plane parallel to the picture surface and all detail is rejected that would detract from the architecture of the scene, which is prevented from becoming too rigid by the slight bend in the dado on the wall behind, echoed in the line of the picture-frames.

At the Piano is Whistler's first masterpiece. It has a solidity, craftsmanship and resonance that make it one of his most satisfying works, yet it was rejected by the Salon of 1859, as was Fantin's *Two Sisters*. An exceptionally large number of works were thrown out that year and the Salon itself, as Baudelaire noted, was dominated by mediocrity. Whistler's painting was instead exhibited in the studio of François Bonvin, where it was admired by Courbet. Failure to get his work accepted by the Salon, combined with the success of his etching (which he knew would receive further encouragement from his brother-in-law), contributed to Whistler's decision to move in 1859 to England. *At the Piano* marks the end of his student years and the onset of artistic independence.

12. Charles Meryon (1821–68): *La Morgue*. About 1850–4. Etching, 21.3 × 18.7 cm. (8⅜ × 7⅜ in.) London, British Museum

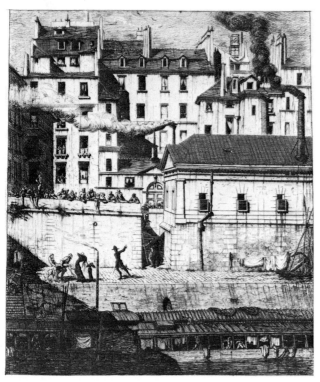

In London, Whistler's base was the Hadens' four-storied house, 62 Sloane Street. The life-style he enjoyed there was one of elegant wealth; champagne frequently accompanied the five-course meals; the area was sufficiently close to Mayfair to be considered fashionable but not ostentatious. He enjoyed a close sympathy with his half-sister, and his relations with Haden also began harmoniously. As Whistler put it, Haden was 'glorying in the artist who let the surgery business slide', having recently renewed his interest in etching, and the two men went on etching trips together out to the fields west of London. Delighted with his new surroundings and the patronage he was beginning to enjoy, Whistler wrote to Fantin and Legros urging them to join him in London. Fantin came for a visit in the summer of 1859 and the two friends went to the Academy's annual exhibition where they admired Millais's *The Vale of Rest* (Tate Gallery). Then, on a return visit to Paris, Whistler found Legros in such a deplorable condition, owing to the recent death of his father, who had left huge debts, that, as he said, 'it needed, well, you know, God or a lesser person to pull him out of it,' and he too was brought to England, where in 1863 he settled for good.

The artist whom Whistler seems to have had very much in mind during 1859 was Charles Meryon. At the Salon that year his etchings of Paris were highly praised by Baudelaire, who wrote, 'I have rarely seen the natural solemnity of an immense city more poetically reproduced.' According to the Pennells, on a brief visit to Paris in the winter of 1859 Whistler attempted to 'rival Meryon' by etching a view of the city from the Galerie d'Apollon in the Louvre, but gave it up before

13. *Rotherhithe*. 1860. Etching, 27.3 × 19.7 cm. (10¾ × 7¾ in.) London, British Museum

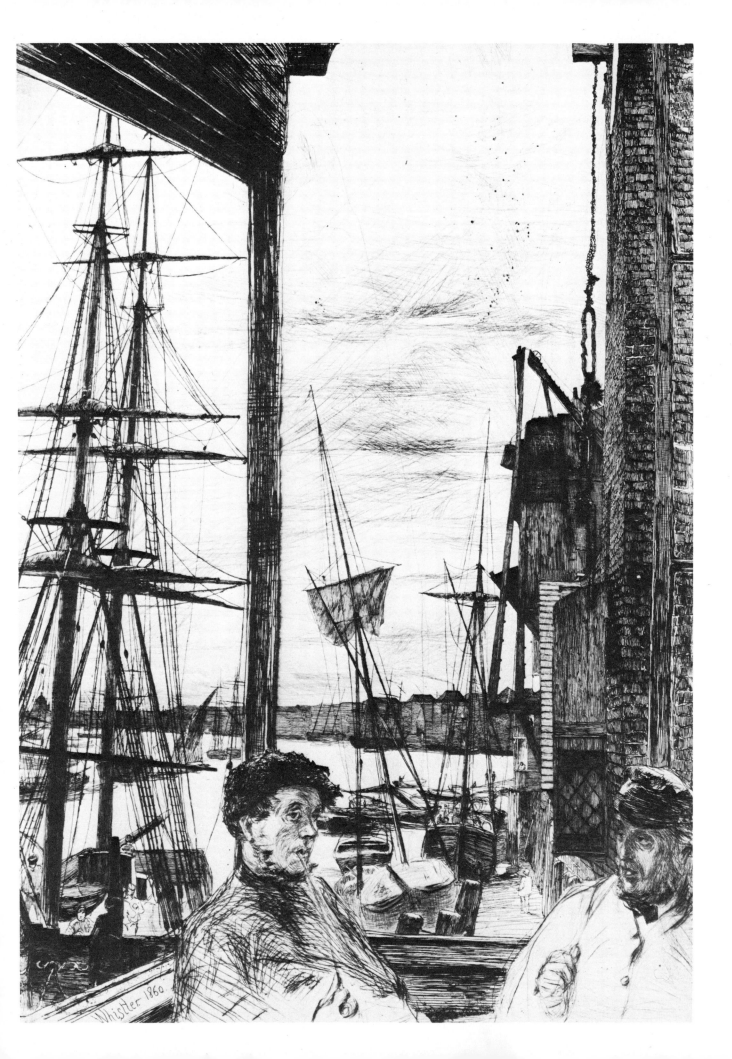

the plate was completed. One of Meryon's prints which Whistler would have known well was *La Morgue* (Plate 12). A copy inscribed with a dedication from Meryon belonged to Félix Bracquemond, the etcher, whom Whistler had met through Fantin-Latour. At one time Haden owned two copies of this print and two preparatory drawings for it. The planar simplification of the composition is similar to that found in *At the Piano* and the suggestion of atmosphere was precisely that which Whistler sought in his own etchings. He may also have been intrigued by the subject—in the lower left two men are carrying to the morgue the corpse of a drowned victim retrieved from the Seine. There was in London one area where men made a living by searching the Thames for whatever flotsam, human or otherwise, the tide which flowed from Southwark Bridge to Millwall threw up. This was Wapping and Rotherhithe, the scene of Whistler's next set of etchings. In 1865, Charles Dickens, whose knowledge of the area was gained on visits to his godfather, made the finding of a body in the Thames by Gaffer Hexham, who makes his living from this dubious occupation, the opening scene of *Our Mutual Friend*. This dockland area was both polluted and corrupt; Dickens described it as, 'down by where accumulated scum of humanity seemed to be washed from higher grounds, like so much moral sewage, and to be pausing until its own weight forced it over the bank and sunk it in the river'.

Attracted to this area partly by its complete contrast with the safe, secure world of Sloane Street, Whistler may also have realized that the view across the river would give him, as it gave Meryon, the necessary distance with which to observe the complex conglomeration of city architecture. Soon after arriving in London Whistler had taken rooms with George Du Maurier in Newman Street, but he was frequently absent from there, staying

instead at the Angel Inn in Cherry Gardens, Rotherhithe. Du Maurier told his mother that Whistler was 'working hard and in secret down in Rotherhithe, among a beastly set of cads and every possible annoyance and misery'. If lacking the more conventional comforts, the area was rich in visual interest:

the river scene presented a confused forest of masts, flags and rigging, set against tall chimneys that belched forth black smoke; on the quay, the merchandise being unpacked was as varied as the pungent smells of tobacco, rum, leather, coffee and spice; the noise was a mingling of shouted orders, singing, hammering, the clanking and rattling of chains, the splash of ropes in the water, and the thunder of barrels as they were rolled along the ground. Amidst it all, mixing happily with tough-fisted bargees, the dandified American was at work on his second masterpiece, *Wapping*, and on his 'Thames Set' etchings.

14. *Wapping*. 1861–4. Canvas, 71 × 101 cm. (28 × 39¾ in.) New York, Mr and Mrs John Hay Whitney

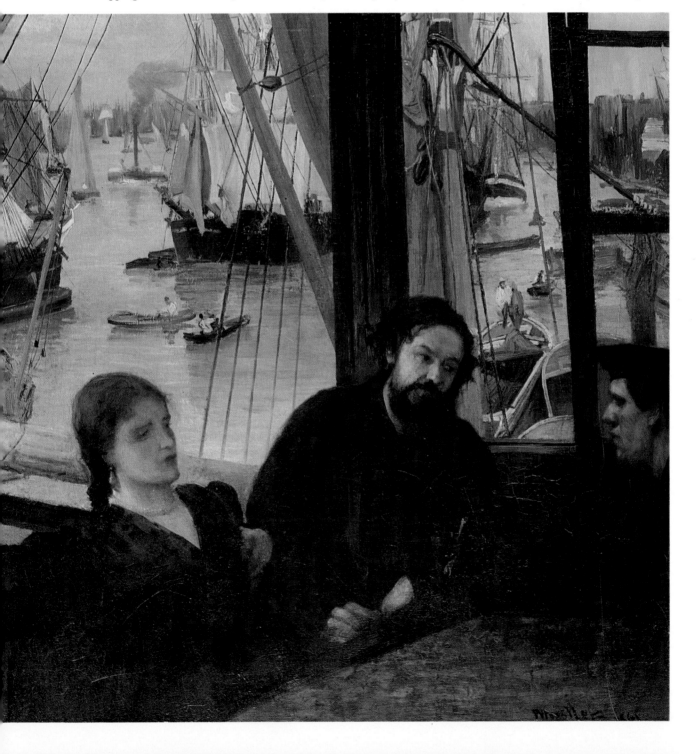

The 'Thames Set' differs from the 'French Set' in a number of ways. The views represented are more spacious, the compositions more subtly designed. The use of hatching to create texture and tone is more controlled and as a result Whistler achieves richer effects with fewer means. His use of line takes on a new freedom, encouraged perhaps by the sweeping lines of the rigging and masts that he drew. In *Rotherhithe* (Plate 13) he varies his treatment for the delineation of flesh, bricks and masts, decreases the darks in the far distance and suggests wispy clouds by the slightest of scratches. It is said that a brick fell while he was at work on this plate, causing him to start and scratch a line down through the sky. He claimed each plate in the 'Thames Set' took him three weeks to

15. *Black Eagle and Adjoining Wharves, Wapping.* About 1860. Photograph. London, Tower Hamlets Libraries

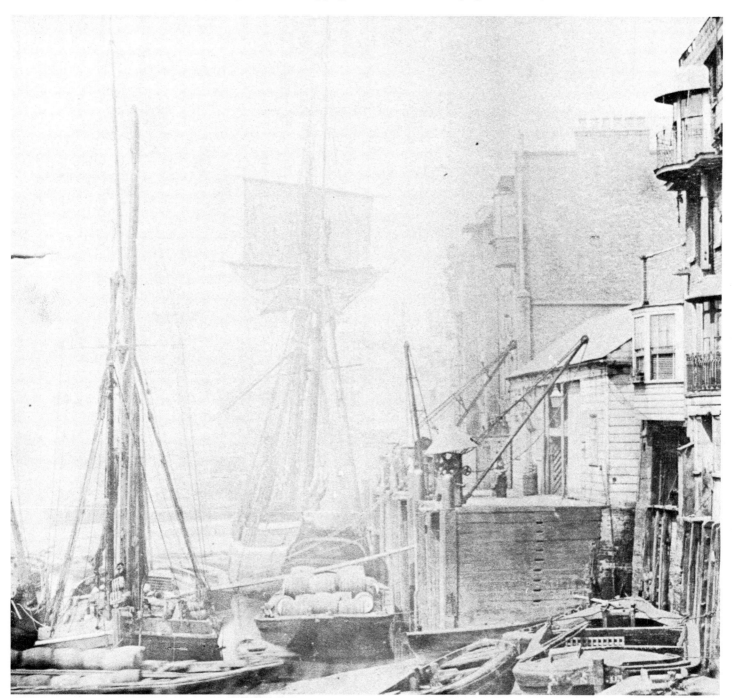

produce, but he probably worked on more than one at a time. For the initial printing, Delâtre was brought over from Paris and the prints were sold by the print-dealer, Serjeant Thomas. When exhibited at the Galerie Martinet in Paris in 1862, they caught the attention of Baudelaire, who wrote of 'wonderful tangles of rigging, yard-arms and rope; farragos of fog, furnaces and corkscrews of smoke; the profound and intricate poetry of a vast capital'.

Baudelaire's description equally applies to the painting, *Wapping* (Plate 14). Although dated 1861 it was not exhibited until 1864 and its completion caused Whistler much difficulty, particularly the three figures in the foreground, which underwent a number of changes. The scene is, as in *Rotherhithe*, the view from the balcony of the Angel Inn, looking across the river towards Wapping. The foreground figures are Whistler's mistress, Joanna Hiffernan (often spelt Heffernan), Legros and a sailor. Originally Whistler intended Jo to be engaged in conversation with the sailor in such a way as to suggest prostitution. Soon after arriving in London he had realized the love of story-telling in British art and his deliberate choice of a scene obviously antagonistic to a Royal Academy audience reflects his mocking scorn of the 'British subject'. In the final result, however, he was after a less obvious, more poetic mood, and the conversation is now between Legros and the sailor, leaving Jo somewhat apart, her red hair glowing dully against the pale stretch of water behind. Again Whistler contrasts figures taking their ease against a busy dockland scene, its ragged confusion throwing into contrast the stillness and intimacy of the foreground group.

Whistler's fine colour sense, as seen in the handling of blacks, greys and browns and the small notes of green and red that echo their way across this picture, is also evident in his

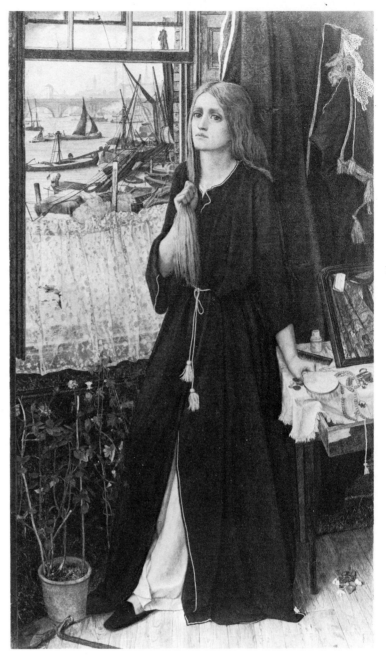

16. Spencer Stanhope (1829–1908): *Thoughts of the Past*. 1859. Canvas, 86.4 × 50.8 cm. (34 × 20 in.) London, Tate Gallery

The Thames in Ice (Plate 18), painted on Christmas Day 1860. The ice is suggested by abrupt, impastoed brushstrokes dragged across the rough surface of the canvas. In the far distance smoking chimneys presage the type of scene to appear in Whistler's work

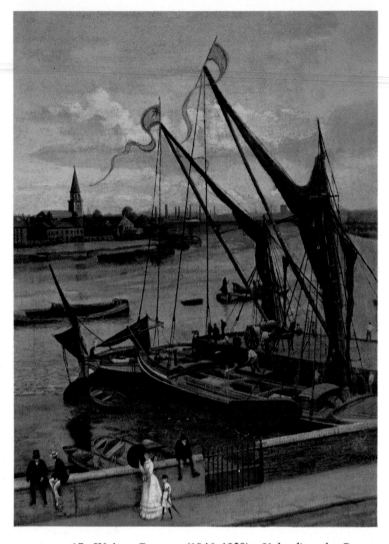

17. Walter Greaves (1846–1930): *Unloading the Barge: Lindsey Jetty and Battersea Church*. About 1860. Canvas, 61 × 45.7 cm. (24 × 18 in.) London, Kensington and Chelsea Libraries

after his move to Chelsea in 1863. The subject may have recalled to mind his experience of the River Neva under ice. Baudelaire believed that 'genius is nothing more nor less than *childhood recovered* at will,' and Whistler's obsession with rivers and the sea reflects an aspect of all the places in which he lived: Stonington looks out over the Atlantic Ocean; Springfield lies on a curve of the Connecticut River; St Petersburg is dominated by the Neva; West Point is on the Hudson River; and in London, Whistler was attracted immediately to the Thames.

These early paintings and etchings of the

Thames have a freshness and originality that spring directly from Whistler's excitement in his subject; but he was not alone in his attraction to the dockland area. D. G. Rossetti lived and worked at Chatham Place, Blackfriars, and in 1858 another Pre-Raphaelite, Spencer Stanhope, also took a studio at Chatham Place and painted *Thoughts of the Past* (Plate 16), in which a girl, who, living where she does, has clearly lost her virginity, stands beside a window through which can be seen a view of the Thames. Whistler, therefore, shared to some extent the current, if fitful, interest in social realism of the Pre-Raphaelites, whose approach was more literary and emotive than that of Courbet. Whistler, however, must still have had Courbet in mind when painting *Wapping*, as he instructed Fantin by letter not to tell Courbet of his subject.

Whistler's life at this time was by no means confined to dockland. He enjoyed the patronage of the Greek family, the Ionides, and frequently dined at their house in Tulse Hill. Concurrently with the 'Thames Set', he painted *Harmony in Green and Rose: The Music Room* (Plate 20), a scene far removed from the harsh trappings of Rotherhithe. The bold asymmetry of this painting, its use of a mirror reflection on the far left and its abrupt perspective, make it far more advanced than anything Degas had produced by this date. It is as if, after the quiet symmetry of *At the Piano*, Whistler felt the need to redesign radically his compositional elements, keeping, however, the bold contrast of black and white and the cutting into the background picture frame by the head of the standing figure to prevent the design becoming too rigid. The figure in black riding dress is about to take her leave and this suggestion of the momentary

18. *The Thames in Ice*. 1860. Canvas, 13.5 × 55.3 cm. (5¼ × 21¾ in.) Washington, Freer Gallery of Art

26

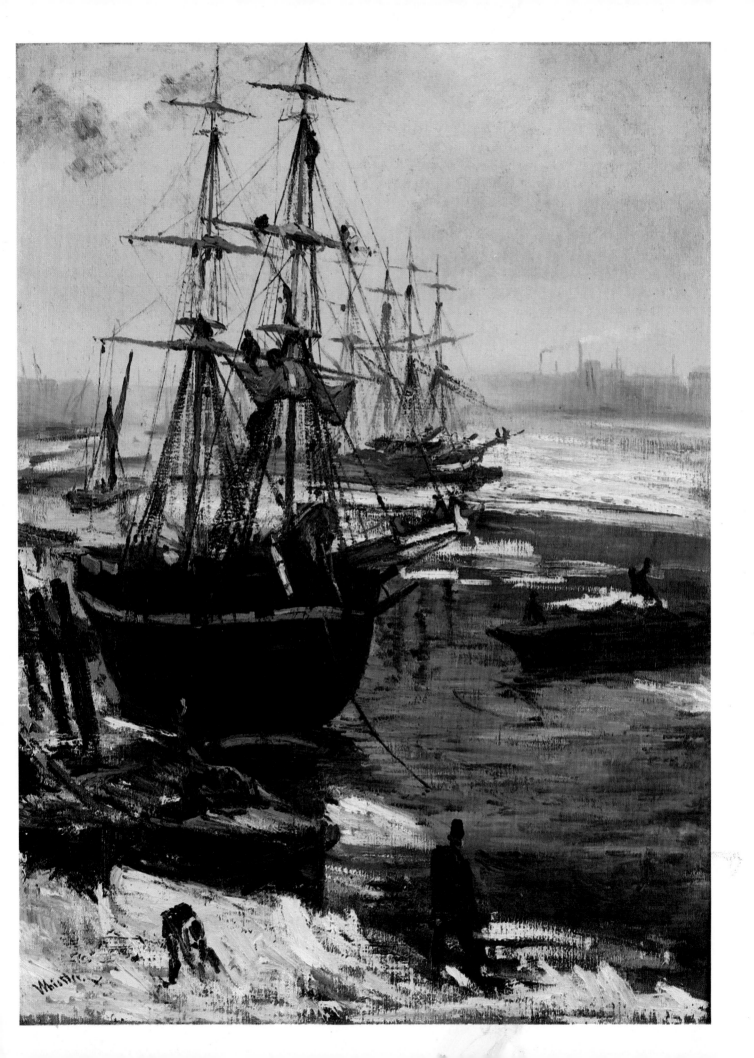

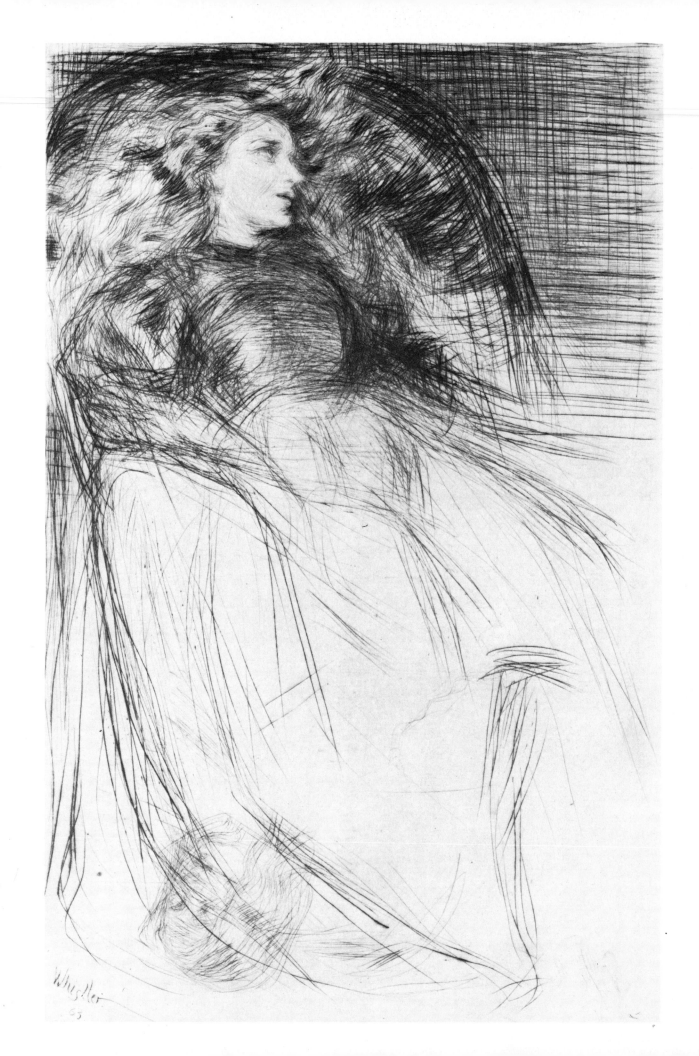

was to be developed in Whistler's full-length portraits. The dominant black of her costume is balanced by the profusion of gaily-coloured chintz curtains and by Annie Haden's white frock.

A cosmopolitan background had given Whistler a certain love of travel and, though based in London until 1892, he made frequent visits abroad. In the summer of 1861 he went on a painting trip to Brittany. The following autumn he set out for Spain, intending to see the paintings by Velasquez in the Prado at Madrid. He reached Fuenterrabia, a fortified town just across the border between France and Spain, but was discouraged by his lack of knowledge of the Spanish language and the difficulties encountered when he tried to paint out-of-doors. Jo, who was with him, was not well, and without going any further he turned his back on the Prado and returned home.

After the Brittany trip in 1861, Whistler took a studio that winter in the Boulevard des Batignolles in Paris, where he began work on *Symphony in White No. 1: The White Girl* (Plate 21). The model was his mistress, Jo, whose character seems to have been very different from that suggested by the painting. Red-haired and Irish, for a few years she managed Whistler's affairs, keeping house for him and assisting him with the sale of his work. To give herself respectability, she called herself Mrs Abbott and was known by that name in Bond Street; her drunken father also referred to Whistler as 'me son-in-law'. Whistler was fascinated by her long red hair, which may have had for him the same erotic appeal that Baudelaire celebrated in his poems, and when he first introduced Jo to Courbet he pulled down her hair to give it full

effect. Courbet also responded to her beauty and painted her combing her hair in *La Belle Irlandaise*, of which four versions exist. Later, in 1866, she posed as one of the two nude women in his *Le Sommeil* (Paris, Petit Palais), a fact that may have contributed to Whistler's decision to break with her.

The White Girl was rejected by the Royal Academy in 1862 and first shown instead at the Berners Street Gallery. In Paris, the following year, it was rejected by the Salon and exhibited instead at the Salon des Refusés, where it competed for attention with Manet's *Déjeuner sur l'Herbe*. Whistler's painting, in both London and Paris, astonished because of the bold decision to place a figure in white against a white background cloth, letting the dim red of her hair balance the cool blue in the rug and the warm tones of the bearskin on which she stands. As has been noted, her far-seeing gaze was probably inspired by that of the nun in Millais's *The Vale of Rest* or by that of the central child in his *Autumn Leaves*, both paintings reflecting a similar wistful mood. Critics were naturally eager to seize upon the central meaning of Whistler's canvas and references were made to Wilkie Collins's popular novel, *The Woman in White*, though Whistler refuted this possible source. The French critic Castagnary, noting the fallen flowers at her feet, probably came closest when he suggested that it represented the uneasy reverie of a young woman on the morning after her bridal night. Another critic, Paul Mantz, preferred to explain it simply in formal terms as a 'symphony in white' and Whistler, appreciating the analogy, later added this phrase to the title. Once, when in 1867 he used this title in connection with another painting of young women, it was criticized on account of other colours used. Whistler replied in characteristic vein: 'Bon Dieu! did the wise person expect white hair and chalked faces? And does he then, in his astounding

19. *Weary*. 1863. Drypoint, 19.7 × 138 cm. (7¾ × 5⅛ in.) London, British Museum

29

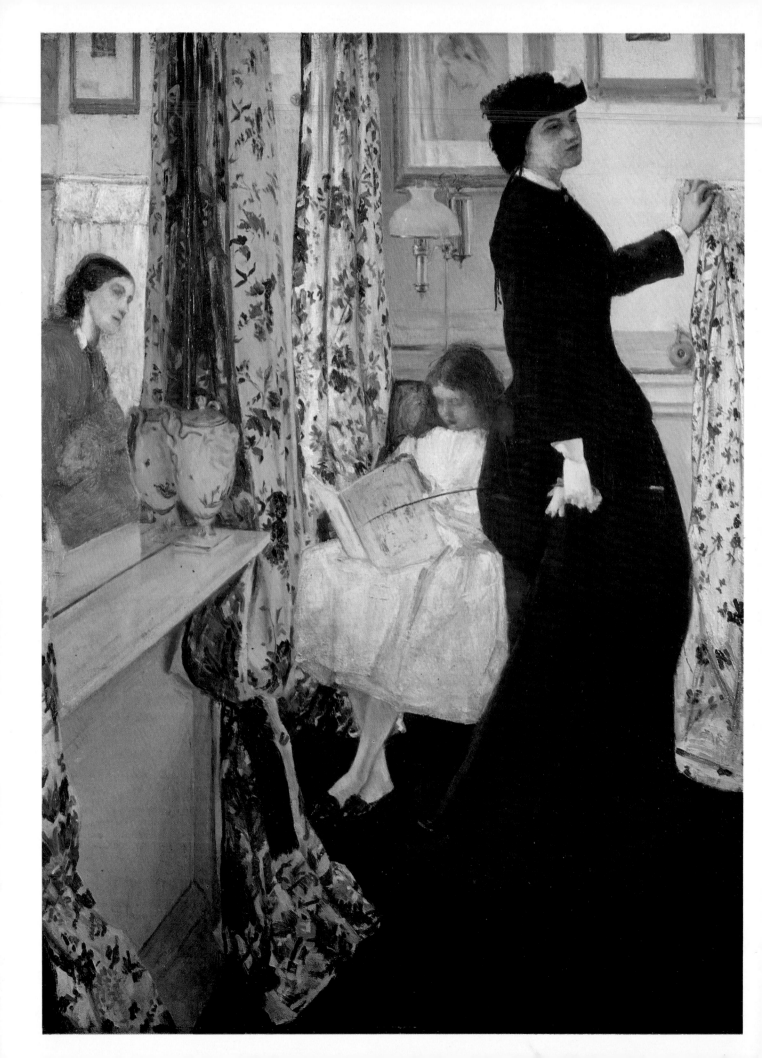

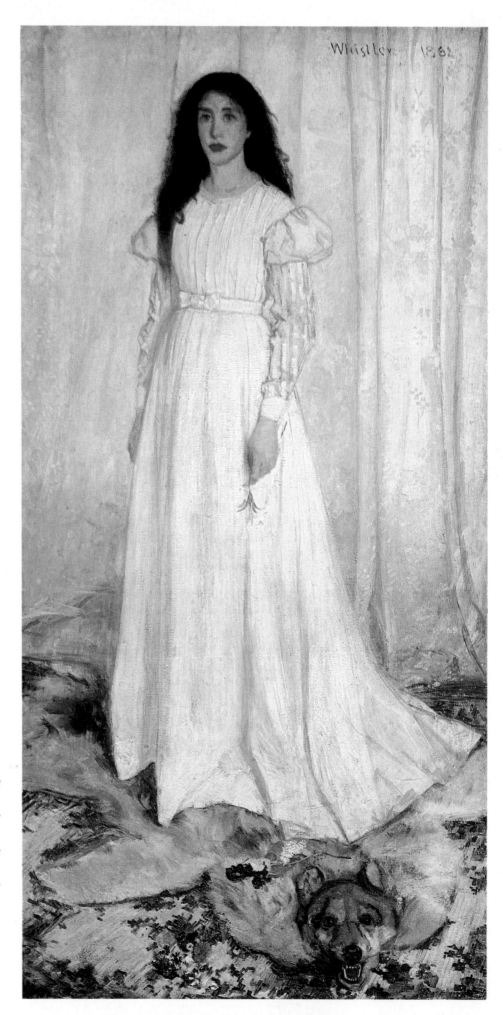

20. *Harmony in Green and Rose: The Music Room.* 1860. Canvas, 95.5 × 70.8 cm. (37⅝ × 27⅞ in.) Washington, Freer Gallery of Art

21. *Symphony in White No. 1: The White Girl.* 1862. Canvas, 214.6 × 108 cm. (84½ × 42½ in.) Washington, National Gallery of Art

consequence, believe that a symphony in F contains no other note, but shall be a continued repetition of F F F? . . . Fool!'

In *The White Girl* Whistler came closest in mood to Pre-Raphaelitism and significantly Courbet was disappointed to discover in the painting *une apparition du spiritisme*. Whistler had gradually become known to his English colleagues since the success of *At the Piano* at the Academy in 1860, which Millais had praised as 'the finest piece of colour that has been on the walls of the Royal Academy for years', but he did not really begin to move in the Pre-Raphaelite circle until 1863 when he moved to 7 Lindsey Row (now Cheyne Walk), in close proximity to Tudor House, which Rossetti had taken in 1862. That year Du Maurier informed Armstrong, 'Jimmy and the Rossetti lot, i.e. Swinburne, George Meredith and Sandys, are as thick as thieves.' If *The White Girl* is as moody and enigmatic as certain paintings by Millais, Whistler's drypoint, *Weary* (Plate 19), shares Rossetti's interest in languorous, sensuous women. Sleep was seen to suggest spiritual remoteness, and, if not asleep, the sitter in *Weary* seems about to expire. Rossetti and Sandys had an obsession with hair, and here Whistler lets it fly out, creating an aureole around the sitter's head. The whip-like movement of the needle over the plate suggests that he was becoming irritated by the limitations of the medium and during the next six years he hardly touched etching at all.

If the move to Chelsea brought Whistler for the next ten years into the company of a leading Pre-Raphaelite, it also brought him the friendship of the Greaves family, who lived at one end of Lindsey Row. The father built and rented boats and had earlier rowed Turner across the river on fine days to the fields at Battersea (now Battersea Park). At 4 Lindsey Row until 1854 had lived the romantic painter, John Martin, who instructed Greaves to knock on his door at night whenever a full moon and clouds were making fine sky effects. One of Greaves's sons, Walter, at the age of sixteen painted a large, lively work, *Hammersmith Bridge on Boat Race Day* (Tate Gallery) in a naïve style. His brother Henry also painted, and these two young men now attached themselves to Whistler; he taught them to paint and they taught him to row with the 'Waterman's jerk' and introduced him to the nearby Cremorne Gardens. Walter Greaves was the more talented of the two, capable of affectionate care in the construction of complex compositions and subtle colouring, as seen in *Unloading the Barge* (Plate 17). Over the next fifteen years he became Whistler's most devoted disciple, not only submerging his personal style in imitation of his art, but adopting also his mannerisms and dress. This dedication brought him little reward. Towards the end of his life, his top hat battered and worn, he haunted the bookshops near the British Museum, offering sketches of his beloved Chelsea in return for books, and eventually died in a poorhouse in 1930.

While this association lasted, Walter Greaves's familiarity with Chelsea and the river introduced Whistler to new subjects. Before the Embankment was built in 1871, putting a barrier between the city and the river and along which thundering traffic now passes, the river bank was little more than a picturesque path. This stretch of river was quieter than London's dockland and provided more contemplative subjects. In the company of the Greaves brothers, Whistler often spent all night on the river making brief notes in chalk on brown paper in preparation for his 'Nocturnes'. On other occasions they would rise at five o'clock in the morning and row up to Putney to breakfast with Rossetti's friend, Charles Augustus Howell.

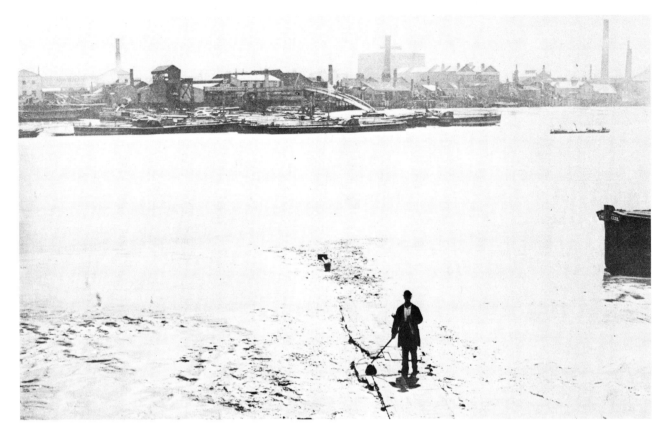

22. James Hedderly (1815–85): *The Foreshore at Low Water opposite Battersea.*
About 1860–70. Photograph, 21.6 × 24.1 cm. (8½ × 9½ in.) London, Kensington and Chelsea Libraries

The change in Whistler's attitude to the river can be seen by comparing *The Last of Old Westminster* (Plate 23) with *Brown and Silver: Old Battersea Bridge* (Plate 24). The former was painted shortly before his move to Chelsea, from the rooms of a friend in Manchester Buildings (now Scotland Yard). From the room-owner's description it appears that Whistler's painting represents not the dismantling of the old bridge but the removal of the scaffolding from the new. Single brushstrokes are used to depict each wooden pile and the figures of the men are indicated by mere touches of the brush. The harsh, impastoed painting of the water and the abrasive treatment of the whole is well suited to the subject of labour. Quite different is the gentle, atmospheric mood of *Old Battersea Bridge*, from which all evidence of his brushwork has been eliminated. Equally noticeable is the different approach to composition.

The diagonal created by the bridge does not recede like that in *The Last of Old Westminster*, but, while suggesting the breadth of river traversed, remains flat and on the surface of the picture. Its compositional force is carefully abutted by two foreground barges whose diagonals, if continued up to the bridge, would intersect it at right angles. This heightened awareness of design reflects the influence of Japanese prints, in which three-dimensional figures and scenery are drawn in such a way that they do not break the flatness of the picture plane.

It is almost certain that Whistler would have seen examples of Japanese prints during his student years in Paris. Through Fantin he had met Félix Bracquemond, who owned a copy of Hokusai's *Mangwa* and showed it at every opportunity. However, Whistler's interest in this art form only began to develop around 1862–3. By 1864 he had become a

33

regular customer of Madame de Soye's shop in Paris, 'La Porte Chinoise', and his letters to Fantin contain frequent references to this shop and to Japanese art. He developed a passion for oriental blue and white china and vied with Rossetti for choice acquisitions. Through Rossetti, Whistler met the dealer in oriental porcelain, Murray Marks, and in 1876 Marks commissioned him to execute several illustrations for a catalogue of blue and white china in the collection of Sir Henry Thompson. So great was Whistler's love of blue and white that on hearing of the massacre of the Ministers in Pekin in 1900, he declared: 'Well, it is the Chinese way of doing things and there is nothing to redress. Better to lose whole armies of Europeans than harm one blue pot!'

As this last statement proves, oriental art confirmed Whistler's belief in 'art for art's sake'. But at first, the influence on his paintings was merely to introduce 'japonaiserie' into his subjects. *Purple and Rose: The Lange Lijzen of the Six Marks* (Plate 28) is one example. Jo, now dressed in a magnificent Chinese robe, is shown, rather unconvincingly, in the act of painting a pot. She is surrounded by other examples of her art, all of which

23. *The Last of Old Westminster*. 1862. Canvas, 61 × 77 cm. (24 × 30 in.) Boston, Museum of Fine Arts

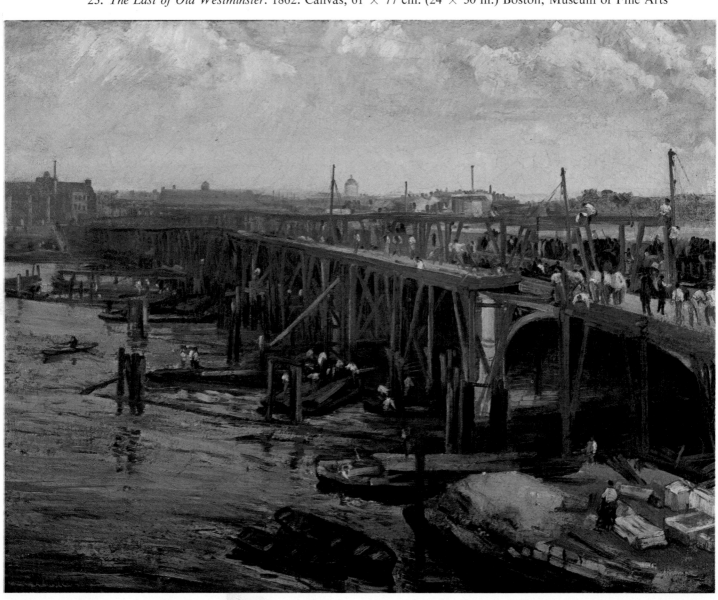

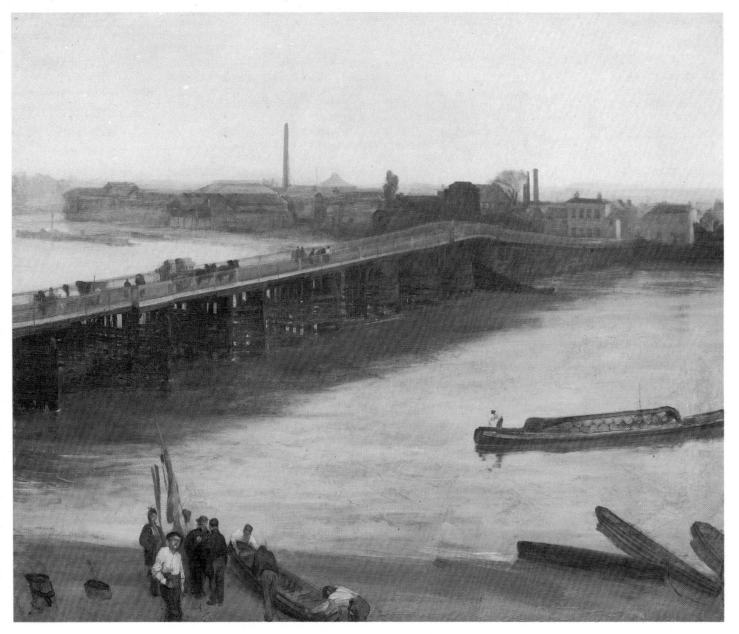

24. *Brown and Silver: Old Battersea Bridge*. Exhibited 1865. Canvas, 63.5 × 76.2 cm. (25 × 30 in.) Andover, Massachusetts, Addison Gallery of American Art

were pieces at that time in Whistler's collection. The title refers to the 'long Lizzies', the elegant female figures often found on these jars, and the 'six marks' to the potter's seals. In the top right-hand corner, Whistler imitates the Japanese artist's method of signing prints. But these accoutrements apart, the painting is more Victorian than oriental, the treatment of space and chiaroscuro still very much part of the Western Renaissance tradition. Yet here and in subsequent paintings, Whistler attempted to imitate the fluidity and assurance with which oriental potters drew on their jars. He began to use thinner paint and this, combined with the Japanese emphasis on selection and flat-patterning, cut across the French tradition of *la belle peinture* and led away from the pursuit of form.

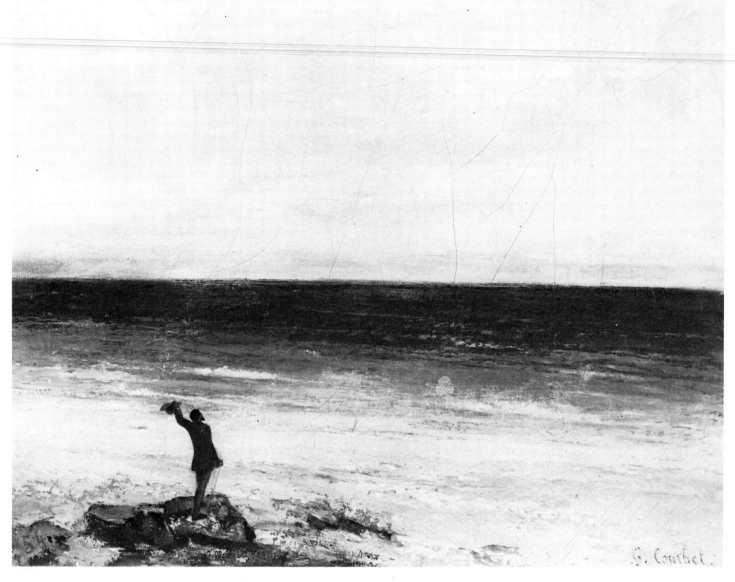

25. Gustave Courbet (1819–77): *Le Bord de la Mer à Palavas*. 1854.
Canvas, 39 × 46 cm. (15¾ × 18⅛ in.) Montpellier, Musée Fabre

The influence of Japanese art can be felt in *Harmony in Blue and Silver: Trouville* (Plate 26), painted in 1865 while Whistler was staying at Trouville. Courbet was also present and his figure appears in the lower left of the painting, in a position reminiscent of Courbet's own *Le Bord de la Mer à Palavas* (Plate 25) of 1853-4. Whistler may have deliberately used Courbet's idea as his starting-point in order to demonstrate more clearly how he differed from the older artist. The higher horizon helps flatten the composition, while space is suggested by the sail in the middle distance, creating a tension between it and the figure of Courbet. It punctuates the smooth thinly-painted surface of the water and is echoed by the suggestion of another sail on the horizon. By comparison with Courbet's painting, Whistler's vision has been de-materialized. The absolute simplicity of means indicates that he had arrived at a new artistic language, but one he was not to use with any

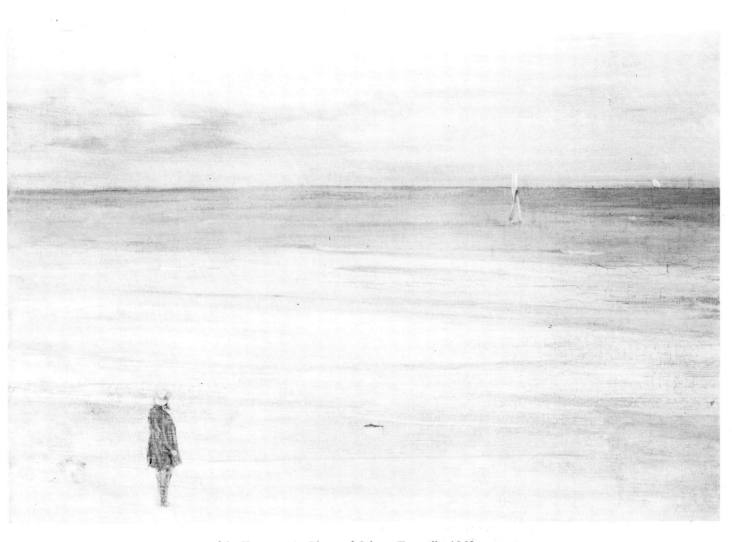

26. *Harmony in Blue and Silver: Trouville*. 1865.
Canvas, 50 × 76 cm. (19⅝ × 29⅞ in.) Boston, Isabella Stewart Gardner Museum

confidence until the early 1870s.

Meanwhile Whistler's personal life was far from secure. His relationship with Seymour Haden had deteriorated beyond repair owing to Haden's patronizing attitude towards his work and that of his friends; and, though Haden had dined happily at Lindsey Row, he forbade his wife to visit her brother because of Jo's permanent residence in the house. This rule continued to apply even after the arrival in London of Whistler's mother towards the end of 1863, when Jo was forced to find separate lodgings. Jo herself was causing Whistler concern. Acting the *grande dame*, she insisted on wearing expensive clothes and was observed by Du Maurier 'got up like a Duchess'. She may also have aroused Whistler's jealousy at Trouville in 1865 by flirting with Courbet. Personal tensions were married with severe doubts about his artistic progress and Whistler wrote bitterly to Fantin of the slowness, hardness

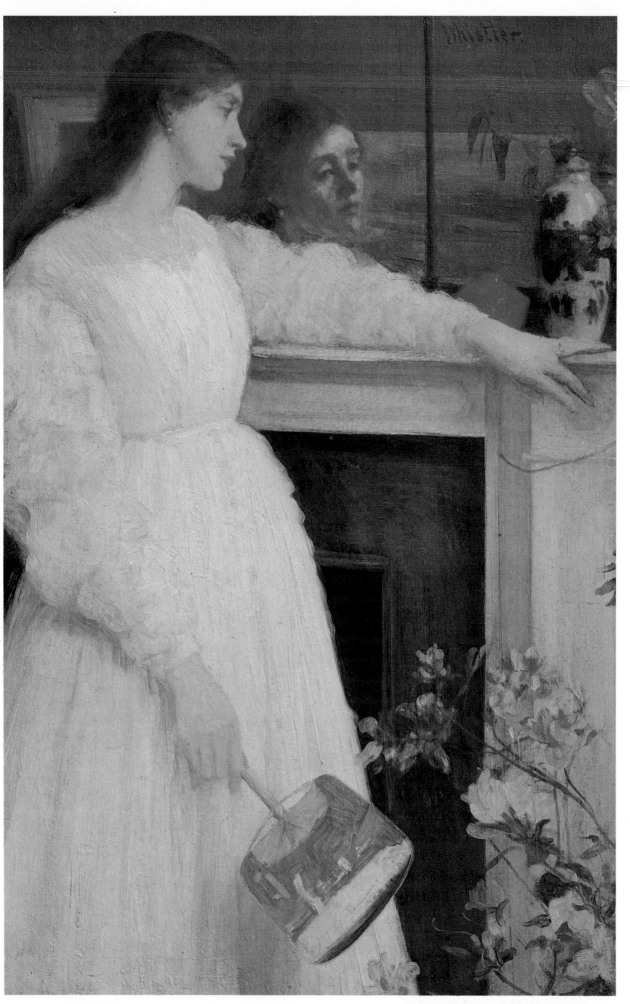

27.
*Symphony in
White No. 2:
The Little
White Girl*.
1864.
Canvas,
76 × 51 cm.
(29⅞ ×
20¼ in.)
London,
Tate Gallery.
The most
famous of
Whistler's
paintings
employing
Japanese
items to
enliven an
essentially
Victorian
subject. The
model is
Joanna
Hiffernan.
Swinburne
was inspired
to write a
poem about
the painting
which
Whistler
then pasted
on the frame

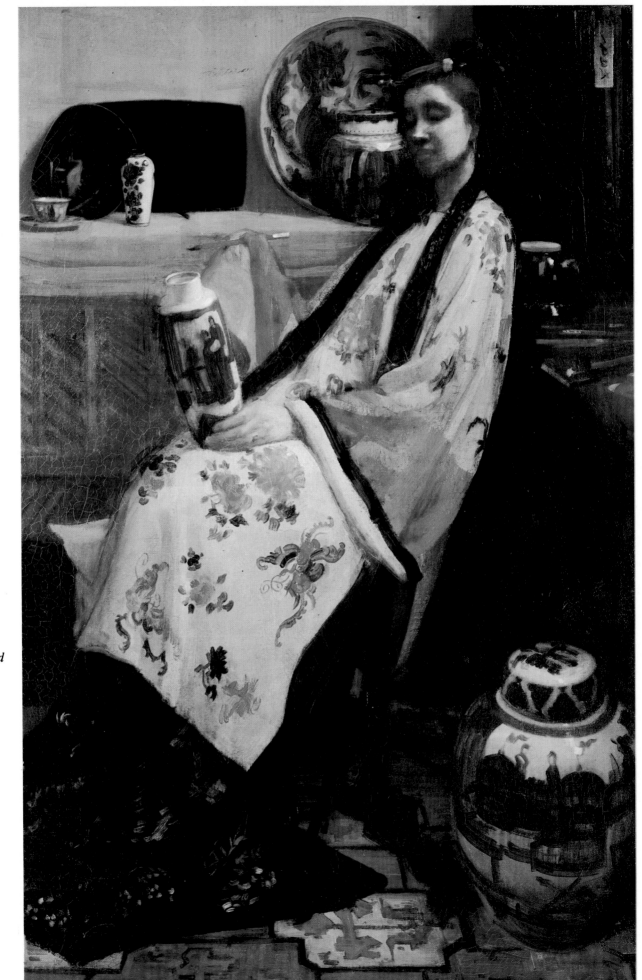

28. *Purple and Rose: The Lange Lijzen of the Six Marks.* 1864. Canvas, 92.1 × 61.6 cm. (36¼ × 24¼ in.) Philadelphia Museum of Art, The John G. Johnson Collection

and uncertainty of his work, complaining that he produced little because he rubbed so much out. His confidence was further undermined by the arrival in London of his brother, who had played an important part as a surgeon in the Southern Army in the American Civil War, while Whistler, trained at West Point, patriotic and devoted to the South, had remained safely in England.

When in 1866 Whistler was approached by some men from West Point and asked to take part in the war being fought by Chile and Peru against Spain, he surprisingly agreed. He had no commitment to Chile, nor was the war one that raised important issues of social rights; the main reason for his sudden departure was surely the weight of problems besetting him in London. On arrival at Valparaiso he saw little more than a skirmish when the Spanish fleet opened fire on the town; his immediate response was to ride out of the town as fast as his horse could carry him. Shortly before this battle occurred he had an experience which became the subject of one of his most evocative paintings, *Crepuscule in Flesh Colour and Green: Valparaiso* (Plates 29 and 38). He gave the following description to the Pennells:

There was the beautiful bay with its curving shores, the town of Valparaiso on one side, on the other, the long line of hills. And there, just at the entrance of the bay, was the Spanish fleet, and in between the English fleet, and the French fleet, and the American fleet, and the Russian fleet, and all the other fleets. And when the morning came, with great circles and sweeps, one after another sailed out into the open sea, until the Spanish fleet alone remained.

The painting represents this moment of dispersal when the ships slowly broke away, unfurled their sails and moved out to sea as daylight broke. Whistler's exact sense of tone enables him to suggest the dusky tones of the half-light. The paint is put on with fluid sweeps of the brush, the lip of paint left at the sides used in the sky to create the edge of the clouds. On the right-hand side pencil drawing can be seen under and, in places, over the paint, suggesting that he worked hurriedly, with few preparations. The slight tilt of the line of the ocean invites the eye into the picture, while the faint ripples in the water create movement that, by contrast, heightens the impression of stillness, of a moment caught, hovering between night and day.

Whistler's trip to Valparaiso did not rid him of his unease. On board ship during his return home, he attacked a Negro, kicking him downstairs, and was confined to his cabin for the rest of the trip. This aggressiveness broke out again soon after his reappearance in London, when he quarrelled with Legros and floored him with a hard blow in the face. In Paris this same year, he quarrelled so violently with Haden that he knocked his brother-in-law through a plate-glass window. At the same time he was becoming increasingly conscious of his personal style, taking great care over the cut of his clothes and moving into a more elegant house in Lindsey Row, No. 2, where he tacked purple Japanese fans on to the blue walls and ceiling of his dining room. By 1869 Jo had been replaced by Louisa Fanny Hanson, about whom little is known except that the following year she bore Whistler a son (christened Charles James Whistler Hanson) and then disappeared, leaving the son to be adopted and raised by Jo.

Not surprisingly, this period of malaise coincides with an artistic crisis in Whistler's career. On his return from South America, he had written to Fantin denouncing the influence of Courbet. He regretted that he had been so swayed by the cult for realism, which he felt had prevented him from gaining a thorough grounding in art. 'If only I had been a pupil of Ingres,' he complained,

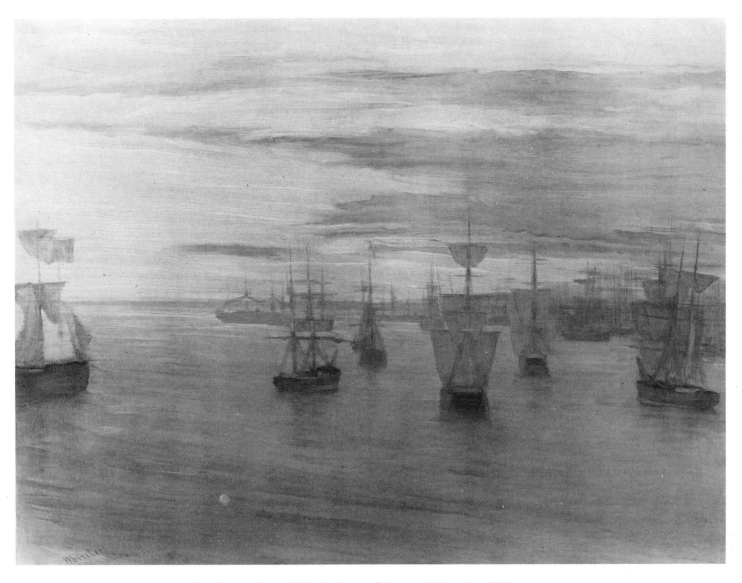

29. *Crepuscule in Flesh Colour and Green: Valparaiso.* 1866.
Canvas, 57.2 × 75.5 (22½ × 29¾ in.) London, Tate Gallery

drawing attention to his lack of skill in drawing and to his desire for a more classical, timeless style than that which realism produced.

Whistler's turning to classicism was encouraged by his friendship with the twenty-four-year-old painter Albert Moore, whom he met in 1865. Moore's interest in classical art had been awakened by a visit to Rome and since then he had made a careful study of the Elgin Marbles in the British Museum, renowned for their anatomical perfection and graceful, flowing draperies. In 1864 and 1865

he exhibited paintings of classically-draped women at the Academy. Both paintings are lost, but the second, *The Marble Seat*, was entirely without literary or allegorical content. Whistler, impressed by Moore's purely decorative aims, wrote to Fantin in August 1865 suggesting that Moore should replace Legros in their 'Société de Trois'. The same letter contains a sketch of a painting on which he was at work, the *Symphony in White No. 3* (Plate 31), but which he did not complete until after his return from Valparaiso. In subject-matter and composition, the painting

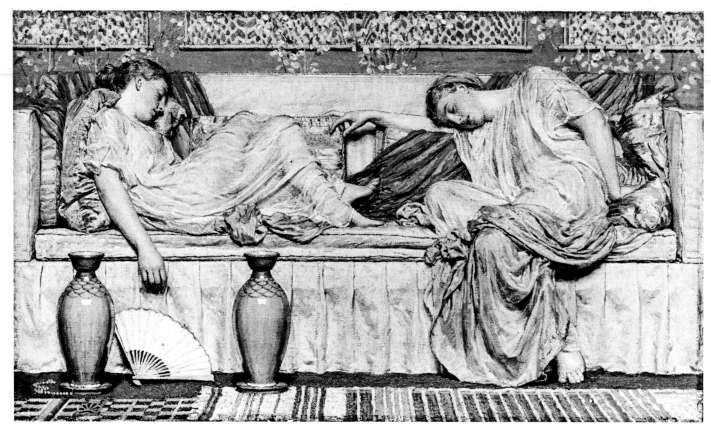

30. Albert Moore (1841–93): *Beads*. About 1875.
Panel, 29.8 × 51.4 cm. (11¾ × 20¼ in.) Edinburgh, National Gallery of Scotland

31. *Symphony in White No.* 3. 1867.
Canvas, 52 × 76.5 cm. (20½ × 30⅛ in.) University of Birmingham, The Barber Institute of Fine Arts

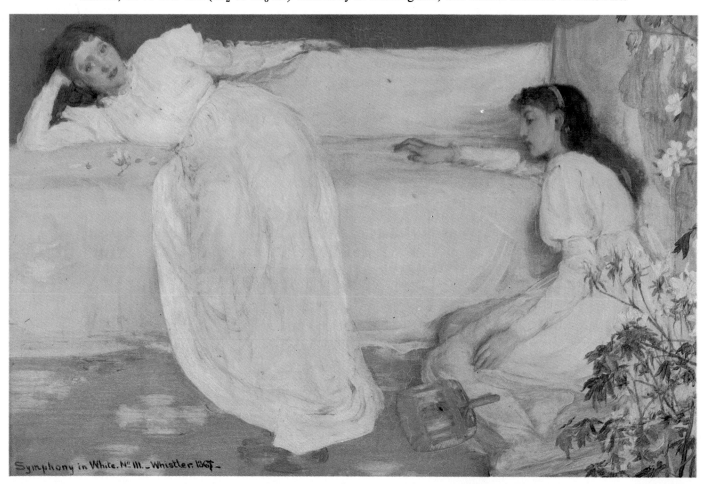

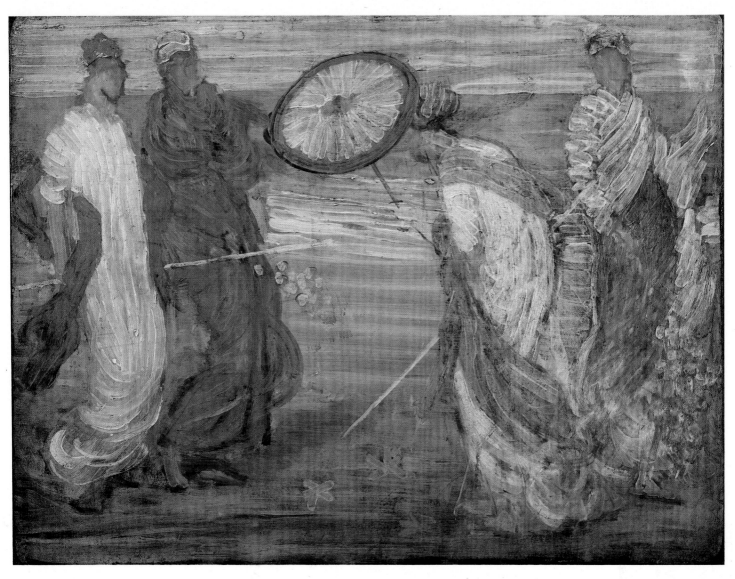

32. *Symphony in Blue and Pink*. About 1868.
Oil on prepared academy board, 46.7 × 61.9 cm. (18⅜ × 24⅜ in.) Washington, Freer Gallery of Art

is indebted to Moore: the two women (Jo and Milly Jones, the wife of an actor) are resting, one on and one beside a white couch, and have no reason for being there other than the satisfying design made by their poses. The cold blue-grey of the carpet is balanced by the note of salmon pink in the Japanese fan. The tone of each colour is carefully chosen to lead up to the brilliant white of Jo's dress. Her presence dominates the composition and the painting of her figure has a lyrical charm and purity which Whistler never surpassed.

If this painting is compared with Moore's *Beads* (Plate 30), the last in a series of three paintings on the same subject initially begun around this date, it can be seen that while Whistler took from Moore his languorous subject-matter and emphasis on the decorative role of draperies, Moore took from Whistler a lighter palette, planar simplification and, in other paintings, Japanese motifs. But there the similarity ends. Moore's harmonious balance of line, colour and form led him to fill every corner of his carefully considered canvas until the painting has a formal richness as seductive as his subject-matter. Whistler's

43

painting is simpler, his colour more subtle, his brushwork softer and more fluid, and on top of this, it has human appeal. The sitters are not anonymous models, but known individuals. Jo gazes straight out at the spectator, charging the scene with a note of psychological enquiry.

Symphony in White No. 3 was followed by two years of uncertainty. Whistler exhibited nothing in 1868 or 1869 and during this time was occupied with his 'Six Projects' (Plate 32), a series of figure paintings in which he attempted to combine the Japanese and Greek influence. Only one ever came near completion, *Three Figures, Pink and Grey* (Tate Gallery) and that he later wanted to destroy. The remaining oil-sketches, which at one time hung on the lemon-yellow walls of one of Whistler's dining rooms, giving the room a warm sunshine effect, were initially begun as a decorative series for his patron, Fredrick Leyland. Whistler was sharing rooms with the architect Frederick Jameson at the time and Jameson recalled that Whistler was beset by doubts and uncertainty. The cocksure dandy was 'painfully aware of his defects' and no sooner was a large portion of a canvas finished than it was 'shaved down to the bed-rock mercilessly'. The oil-sketches clearly reveal Whistler's desire for directness and simplicity in the handling of paint, to achieve his effects at *premier coup*; and the decorative subject, of elegant women posed on the sea-shore against a high horizon, has no other content than beauty—of line, colour, design and pose.

Behind these charming but ultimately vacuous paintings lies the influence of Swinburne. In 1866 the poet, in an article on Blake, had roundly declared that art was divorced from morality and that an ethical message was unnecessary in art. Two years later, in an essay 'Some Pictures of 1868', he found in the work of Moore and Whistler an illustration

44

33. *Draped Figure with Fan on Balcony*. About 1867. Pencil, 26 × 17 cm. (10 × 6¾ in.) University of Glasgow, Hunterian Art Gallery

34. *Variations in Flesh Colour and Green: The Balcony*. About 1864–70. Panel, 61.6 × 36.2 cm. (24¼ × 14¼ in.) Washington, Freer Gallery of Art

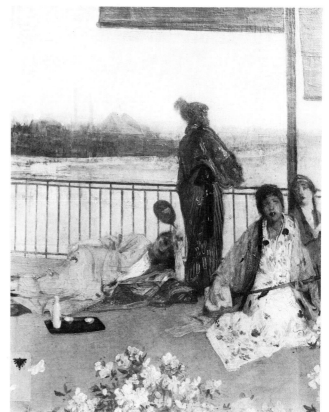

of his belief in 'art for art's sake'. He praised Whistler's 'Six Projects', which he must have seen in his studio, and, appreciating the analogy with music that both Moore and Whistler were making in their art, wrote of Moore's painting: 'The melody of colour, the symphony of form is complete.' If Swinburne's essay reflects to some extent his conversations with Whistler, the poet's emphasis on the worship of beauty gave a coherence to Whistler's aesthetic, which had previously been put together intuitively. 'The worship of beauty,' wrote Swinburne, 'though beauty be itself transformed and incarnate in shapes diverse without end, must be simple and absolute.'

Around 1870 Whistler's artistic ideas gradually moved towards resolution. In *The Balcony* (Plate 34), begun in 1864 but not completed until 1870, the Japanese influence finally triumphed over the Greek, not merely in the choice of motifs which relate directly to Kiyonaga's woodcuts, *The Twelve Months in the South*, but also in the compositional principles underlying the design. As in Kiyonaga's *Sixth Month* (Plate 35), Whistler places his figures against a horizontal and vertical framework and uses the standing figure leaning on the balcony to unite the foreground with the distant view. He also adopts the use of Japanese screens in one corner to help frame the composition. In spite of the piecemeal result, the painting is governed by a heightened awareness of the tension between three-dimensional representation and two-dimensional design, as can be seen by his play on illusion and reality in the lower left corner, where a real butterfly crosses the flat tablet containing the butterfly signature that Whistler had adopted around 1866.

The same schematic division of the picture surface as is found in *The Balcony* governs *Arrangement in Grey and Black No. 1: The*

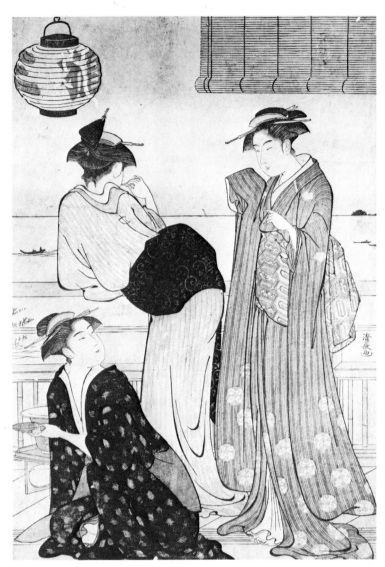

35. Torii Kiyonaga (1752–1815): *The Sixth Month* from *Twelve Months in the South*. 1784. Woodcut, 36.7 × 25.7 cm. (14½ × 10⅛ in.) London, British Museum

Artist's Mother (Plate 37). Here Whistler returns to the domestic subject and planar severity of *At the Piano*, abandoning the sweet colours of *The Balcony* in favour of a subtle range of low tones and the dominant use of black. The complete change of mood, from the artificial flamboyance of the 'Six Projects' to the quiet sincerity of *The Artist's Mother*, must partly have been determined by the sitter's character. Quiet, reserved, pious and shy, Anna Mathilda's friends spoke of her as

45

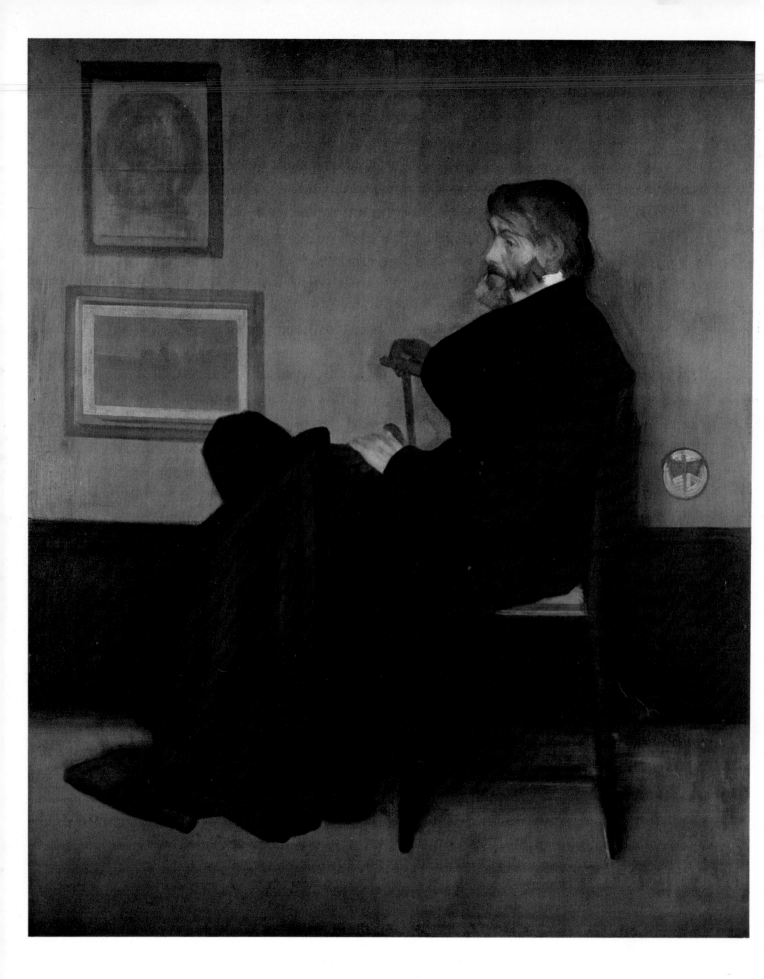

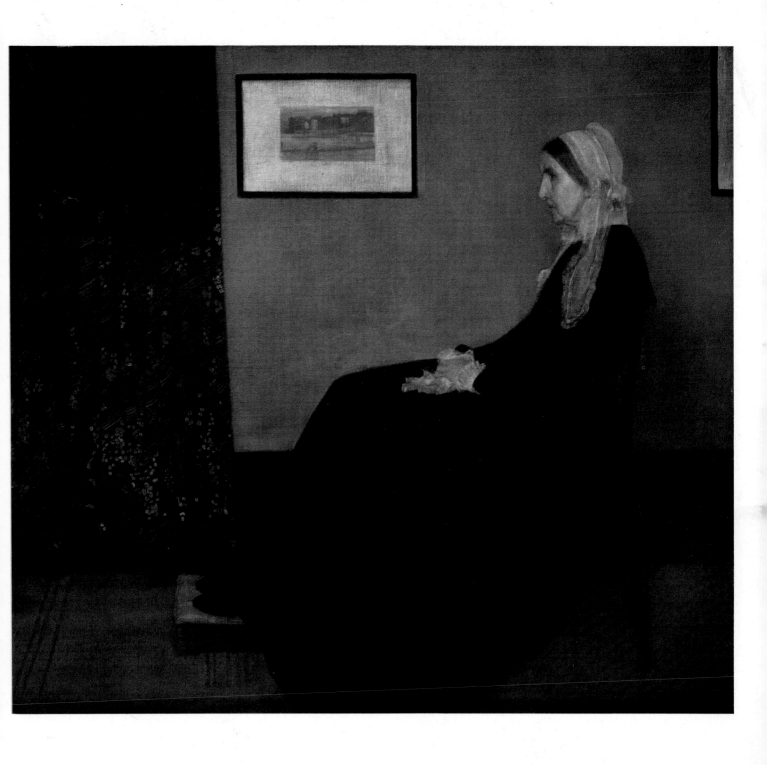

36. *Arrangement in Grey and Black No. 2: Thomas
Carlyle.* 1872–3. Canvas, 171 × 143.5 cm. (67⅜ × 56½ in.)
Glasgow, City Art Gallery and Museum

37. *Arrangement in Grey and Black No. 1: The Artist's
Mother.* First exhibited 1872. Canvas, 145 × 164 cm.
(57⅞ × 64⅝ in.) Paris, Louvre

47

'one of the saints upon earth', and in company she would seek out the corners of rooms and sit quietly sewing. Whistler originally conceived of a portrait of his mother in 1867 and this may explain why, unlike some of his portraits, it was completed in a matter of months when eventually painted in 1871. He originally intended to paint her standing, but a recent illness had left her too weak to hold the pose. Her inner quietness made her an ideal subject and she sat patiently while her nervous son rubbed out one attempt after another in his search for perfection. She, meanwhile, prayed for a miracle. Finally, the portrait was completed to Whistler's satisfaction and he kissed his mother. He had achieved his results with the most limited means, the paint in places merely staining the canvas, the transparency of the head-dress suggested by thinly-scumbled paint, the delicate, uneven grey-green on the wall behind achieved by use of glazes and the whole brought to life by the dancing pattern of lines and dots, a kind of visual fugue, on the curtain to the left of the figure. In keeping with the sitter's deep religious convictions, the portrait exudes a mood of quiet devotion.

Thomas Carlyle, the 'Sage of Chelsea', when taken to see this portrait, declared it had 'massive originality'. He agreed to sit for his own portrait in a similar pose and the result, also entitled *Arrangement in Grey and Black*, has obvious similarities (Plate 36). Technically, the Carlyle is looser in execution than *The Artist's Mother*, the linearity more pronounced, the accoutrements positioned to give more movement to the composition, and the mood, though still introspective, less introverted. It is doubtful if Whistler had read much of Carlyle's colossal output; perhaps he knew of his comparison of the spiritual faith of his day with that of the Middle Ages in *Past and Present* and of his weariness of the age in which he lived. A familiar figure in Chelsea, Carlyle had converted his attic in Cheyne Row into a double-walled garret to keep out the noise of 'dogs, cocks, pianofortes and insipid men'. When he sat for his portrait, his wife had died eight years before; he was described during the last years of his life as 'a gloomily serious, silent and sad old man gazing into the final chasm of things'. His attitude of mind is well summed up in his reply to the villager who remarked that it was a fine day—'Tell me something, mon, I dinna ken.'

As can be seen from the painting, Whistler had the greatest difficulty with the outline of the coat and the positioning of the gloved hand. He was after the same studied elegance that he admired in Titian's *Man with the Glove* in the Louvre, as well as the sombre tonalities and limpid, flowing execution that he admired in Velasquez's paintings. This latter quality he had more opportunity to pursue in his *Harmony in Grey and Green: Miss Cicely Alexander* (Plate 43), painted at the same time as the Carlyle. Of all these three portraits, this has the greatest openness of touch, the paint being freely manipulated in the creation of the dress, the matting and the floating feather of her hat, the grey circle of which gives the right note of weight to the lower part of the composition and positions the figure. Whistler himself designed the dress and specified how it should be laundered. It contributes to the lightness and grace of the portrait in the same way that the pair of butterflies in the top left add to the poise of the whole by creating an imaginary diagonal in relation to the head and the daisies which pulls against the directional movement of the pose.

38. *Crepuscule in Flesh Colour and Green: Valparaiso* (detail of Plate 29)

Concurrently with these portraits Whistler produced a series of 'Nocturnes'—paintings of the Thames at night. The view across the river from Lindsey Row, and that on the same side a little below Chelsea, was a complex pile of warehouses, factories and smoking chimneys, an industrial eyesore to most, but to Whistler a subject that he had already used in the far distance in *The Thames in Ice* and in *The Balcony*. He was attracted to dusk and night because the absence of light caused forms to be simplified and colours to be lost in one general hue. With detail reduced, Whistler could concentrate on achieving decorative harmonies with the simplest of means. He had first painted a 'Nocturne' at Valparaiso, but in the early 1870s he developed a system and a formula which he could vary with subtle effect. He would mix his colours beforehand, using a lot of medium, until he had, as he called it, a 'sauce'. Then, on a canvas often prepared with a red ground to force up the blues and suggest darkness behind, he would pour on the fluid paint, often painting on the floor to prevent the paint running off, and, with long strokes of the brush pulled from one side to the other, would create the sky, buildings and river, subtly altering the tones where necessary and blending them with the utmost skill. The general scene would then be punctuated with a barge or a small figure, and the lights on the far bank would create with their reflections stabbing verticals in the horizontal wash of colour. Out of the decorative unity he creates grow atmosphere and mystery, the sense that the visible world thinly veils the inexplicable.

Whistler's 'Nocturnes' evoke a mood of tenderness and poetry similar to that expressed in 1885 in his *Ten o'Clock Lecture*, a mood distilled from his experience of long nights spent on the river in the company of the Greaves brothers.

And when the evening mist clothes the riverside with poetry, as with a veil, and the poor buildings lose themselves in the dim sky, and the tall chimneys become campanili, and the warehouses are palaces in the night, and the whole city hangs in the heavens, and fairyland is before us—then the wayfarer hastens home; the working man and the cultured one, the wise man and the one of pleasure, cease to understand, as they have ceased to see, and Nature, who, for once, has sung in tune, sings her exquisite song to the artist alone, her son and her master—her son in that he loves her, her master in that he knows her.

One of the most famous is *Nocturne in Blue and Gold: Old Battersea Bridge* (Plate 41), a subject possibly suggested by Walter Greaves and given its form by a Hiroshige print. Whistler balances the massive pile of the bridge (exaggerated for compositional purposes) against the delicate shower of gold created by the firework. He changes the tone from one side of the bridge to the other in order to suggest distance, while the faint rippling of water in the foreground invites the eye into the canvas. A single note of red gives the necessary warmth to the composition, as the Meryonesque figure on the foreground barge gives it human scale. The silvery light reminds that Whistler originally called these paintings 'moonlights', but his patron Frederick Leyland, an enthusiastic pianist and probably familiar with Chopin's music, suggested the term 'Nocturne'. Whistler replied, 'I can't thank you too much for the name Nocturne as the title for my Moonlights. You have no idea what an irritation it proves to the critics, and consequent pleasure to me; besides it is really so charming, and does so poetically say all I want to say and *no more* than I wish.'

Whistler's assessment that his 'Nocturnes' would anger the critics was not mistaken. Ruskin, when faced with *The Falling Rocket* (Plate 48) and other night scenes at the opening

exhibition of the Grosvenor Gallery in 1877, was so outraged that he broke out in print with harsh invective: 'I have seen and heard, much of Cockney impudence before now; but never expected to hear a coxcomb ask two hundred guineas for flinging a pot of paint in the public's face.' Whistler showed this passage to a friend who suggested that it constituted libel and the result was the famous Whistler v. Ruskin trial, which Whistler, largely through his wit and sense of timing, won. The battle involved two opposing artistic philosophies: whereas for Ruskin art was inextricably bound up with ethics and could and should act as a moral directive, Whistler believed that art stood apart from practical life, offering a pure experience untouched by moral necessity. 'Art', said Whistler, 'should be independent of all clap-trap, should stand alone, and appeal to the artistic sense of eye or ear, without confounding this with emotions entirely foreign to it, as devotion, pity, love, patriotism and the like.'

Whistler had to wait over a year for this trial to take place and in the meantime he lost the support of his leading patron, Frederick Leyland, to whom he had first been introduced by Rossetti. Leyland was a self-made Liverpool shipowner, wealthy and influential, who found collecting one outlet for those energies not satisfied by his business interests. On his return home at night he would go straight up to his room and furiously practise scales on the piano. Tall, lean, bearded, he was, Whistler thought, 'portentously solemn'. He generously patronized contemporary artists, including a number of Whistler's friends, and for this earned the nickname the 'Liverpool Medici'. Since the autumn of 1869 Whistler had been a regular visitor at Leyland's manor house, Speke Hall, eight miles from Liverpool, where his interest in etching revived and he executed plates of

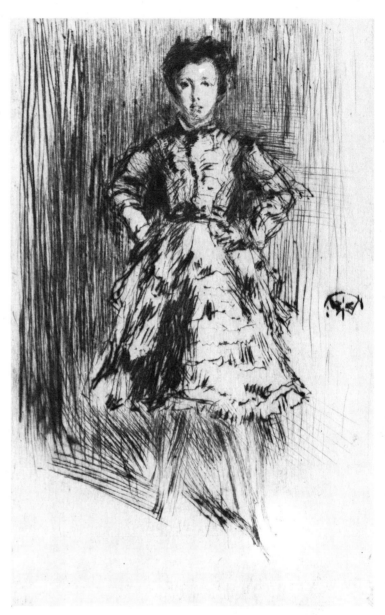

39. *Elinor Leyland*. 1873. Drypoint, 21.3 × 14 cm. (8⅜ × 5½ in.) London, British Museum

Liverpool docks and of Leyland's family (Plate 39). Leyland's three daughters and son delighted in Whistler, as did his wife, who enjoyed with the artist an *amitié amoureuse*. Full-length portraits of both husband and wife were commissioned and work continued

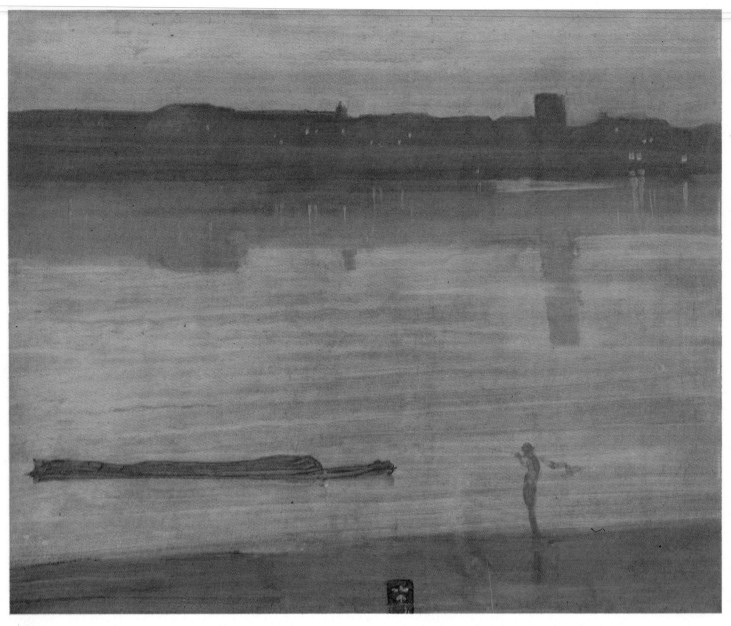

40. *Nocturne in Blue and Green: Chelsea*. About 1870. Panel, 48.2 × 39.8 cm. (19 × 15¾ in.) London, Tate Gallery

41. *Nocturne in Blue and Gold: Old Battersea Bridge*. About 1872–5. Canvas, 66.6 × 50.2 cm. (26¼ × 19¾in.) London, Tate Gallery

on these in both Liverpool and London. For *Symphony in Flesh Colour and Pink: Mrs F. R. Leyland* (Plate 44) Whistler again designed the dress and seized on a pose, adopted unconsciously by the sitter while talking, that struck just the right note of negligent elegance.

But the good relations that Whistler enjoyed with his forbearing patron and his attractive wife turned to bitter hatred over the decoration of the famous Peacock Room.

The Peacock Room was the dining room at 49 Princes Gate, Leyland's London home.

52

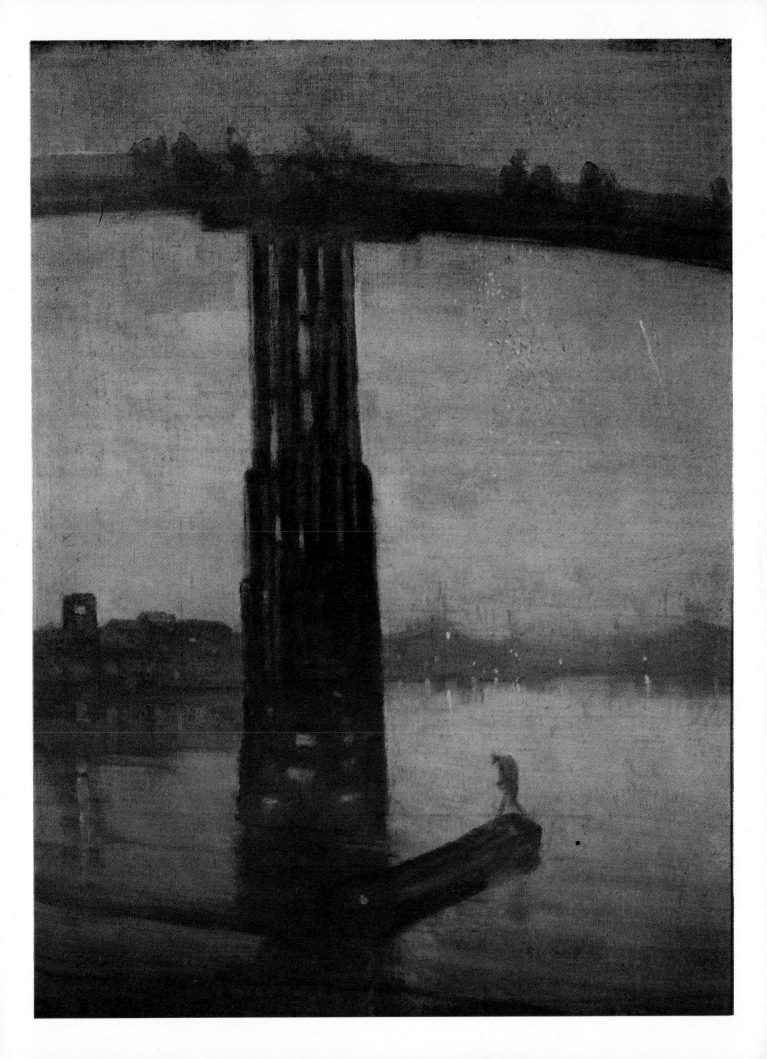

At first, he brought in the architect Thomas Jeckyll to redesign the room in a way that would house his collection of blue and white china. Jeckyll (whose most notable achievement seems to have been a pair of wrought iron gates, now at Sandringham) covered the walls with leather (alternately described as Cordovan or Norwich) imprinted with red flowers and constructed an elaborate system of shelving, suitably Japanese in style, to house the china. Overhead hung an incongruous Jacobean ceiling with large gaslights affixed to its pendants. 'To speak most tenderly,' wrote the architect E. W. Godwin, 'it was at the best a trifle mixed.' Jeckyll then hesitated as to what colours he should choose for the doors and window frames and Mrs Leyland wrote to Whistler for advice. Whistler's main criticism was that the red border in the carpet and the red flowers in the leather did not harmonize with his *La Princesse du Pays de la Porcelaine* (one of his oriental subjects produced during the early 1860s), which hung in pride of place over the mantelpiece. He asked permission to retouch the leather and make other small alterations. No contract was drawn up and the exact agreement between patron and artist remains unclear. Leyland, distracted by shipping worries, left for Liverpool and from that moment Whistler regarded the room as his own.

After finding the retouching of the leather inadequate, Whistler, aided by the Greaves brothers, began to repaint the entire room a deep blue. He had earlier chosen blue for his own dining room at Lindsey Row, but the final effect of the Peacock Room was very different from the restrained, uncluttered interiors he normally favoured—the product of his New England background, his admira-

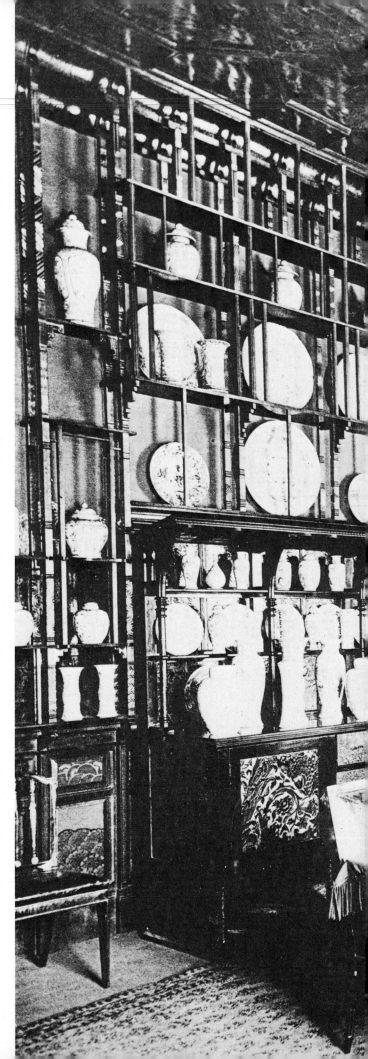

42. The Peacock Room, Princes Gate, showing *La Princesse du Pays de la Porcelaine*. 1876–7. Photograph (1892) University of Glasgow, Library

54

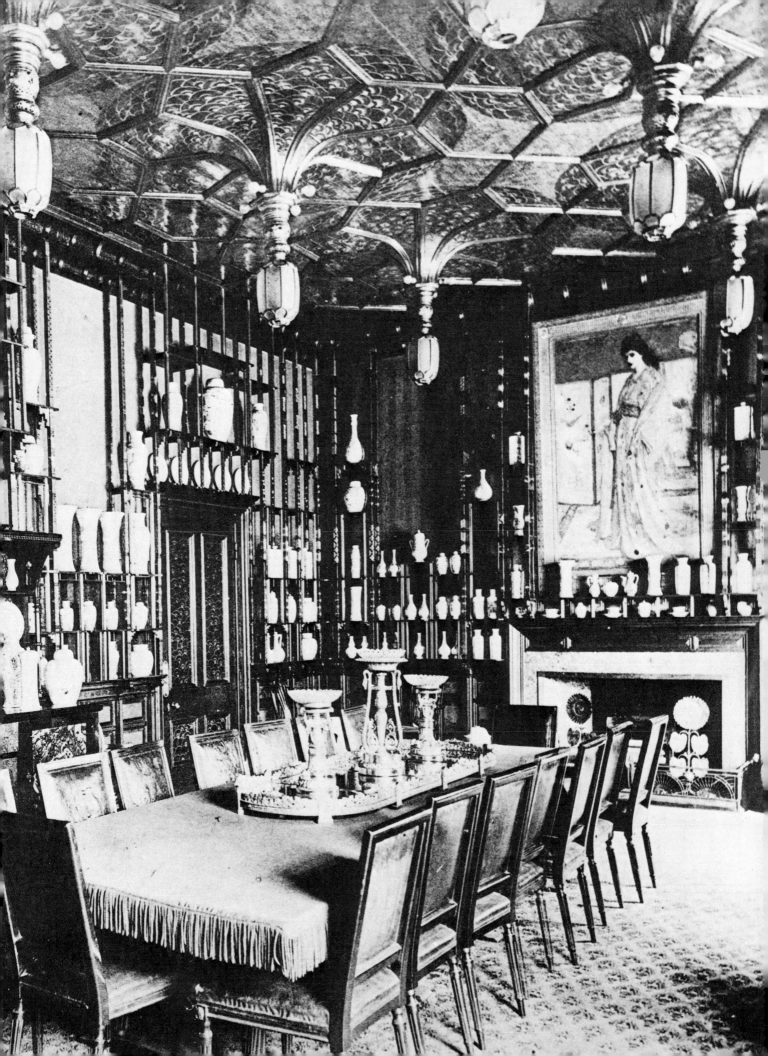

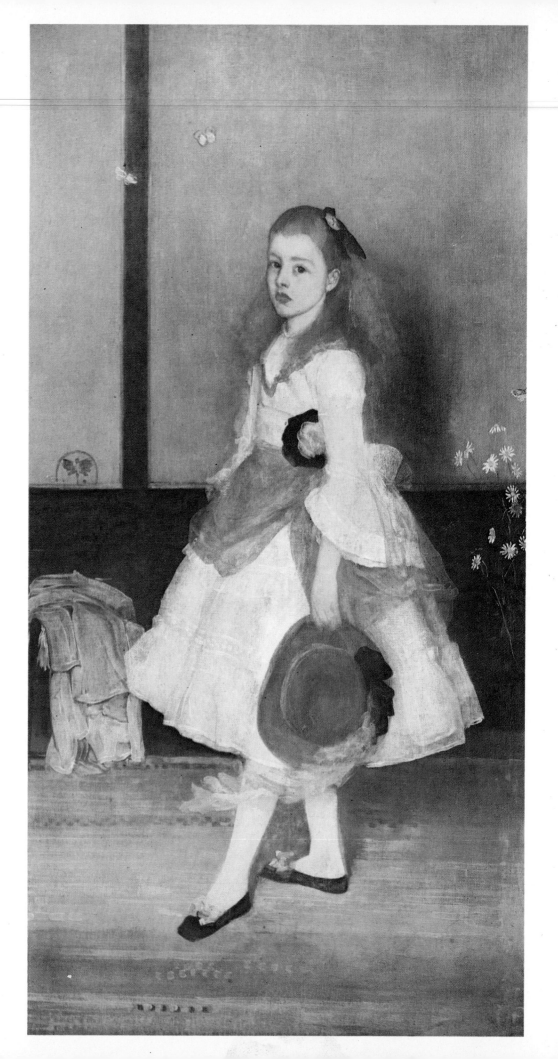

43. *Harmony in Grey and Green: Miss Cicely Alexander.* About 1872–4. Canvas, 218.4 × 99 cm. (86 × 39 in.) London, Tate Gallery

56

44. *Symphony in Flesh Colour and Pink: Mrs F. R. Leyland.* 1873. Canvas, 189.5 × 96 cm. (74⅝ × 37¾ in.) New York, The Frick Collection

45. Peacock Room. Etching by E. Mitchell. 1892. 14.8 × 17.5 cm. (5⅞ × 6⅞ in.) University of Glasgow Library

tion for Japanese art and his friendship with the 'aesthetic' architect, E. W. Godwin. Instead of austerity and restraint, the Peacock Room glitters and sparkles with gold, the shelves being gilt with gold-leaf and the shutters of the windows decorated with designs of peacocks, their elaborate feathers showering out like a flood of gold coins. As if this were not enough, Whistler picked up the motif of the eye and breast feather of the peacock in decorative waves around the walls.

'I just painted it as I went on,' he later said of the room, 'without design or sketch.' As it grew in importance for him, he moved into 49 Princes Gate and worked from dawn to dusk. When it approached completion he had a pamphlet printed on the room and sent it to the press, at the same time sending out cards of admission and leaving others at Liberty's to interest the public. Convinced that he had produced the most beautiful room in all London, Whistler, in his arrogance, was led

to abuse his patron. On a visit to the house, Mrs Leyland overheard him say, 'Well, what can you expect from a parvenu?' He was ordered out of the house, but allowed back to complete some finishing touches on the shutters.

Leyland, insulted by Whistler's behaviour and furious that his private home had been turned into a public gallery, was then presented with a bill for two thousand guineas. Considering Whistler already owed Leyland one thousand pounds in advances for undelivered paintings, the thousand pound cheque he now received was not ungenerous; but only tradesmen were paid in pounds, not guineas, and Whistler was infuriated by the absence of shillings. A long and violent quarrel ensued in which Leyland wrote Whistler one of the most damning letters he ever received, pointing to his inability to complete any serious work and to the degradation of his character: 'The fact is your vanity has completely blinded you to all the usages of civilized life, and your swaggering self-assertion has made you an unbearable nuisance to everyone who comes in contact with you.'

The loss of Leyland as a patron and the effect of Ruskin's harsh criticism left Whistler in an unhealthy financial position. This did not prevent him from commissioning Godwin to build him the White House in Tite Street, which was completed in the autumn of 1878. The Whistler v. Ruskin trial was heard on November 25 and 26 of that year and, though victorious, Whistler was awarded only a farthing in damages and faced a thousand pounds in costs. In May the following year he was declared bankrupt and in September the White House was sold and its contents dispersed, several of Whistler's paintings having already been deposited with the printers Messrs Graves as security for financial loans. Whistler, living a hand-to-mouth existence,

46. Photograph of Whistler. Published by the London Stereoscopic Company. London, National Portrait Gallery

was even forced to part with *The Artist's Mother*, which with two 'Nocturnes' fetched a loan of one hundred pounds. Not surprisingly, at a meeting of his creditors, the man who lived with his nerves always seething beneath a veneer of refinement lost control and broke out in a tirade against British millionaires.

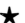

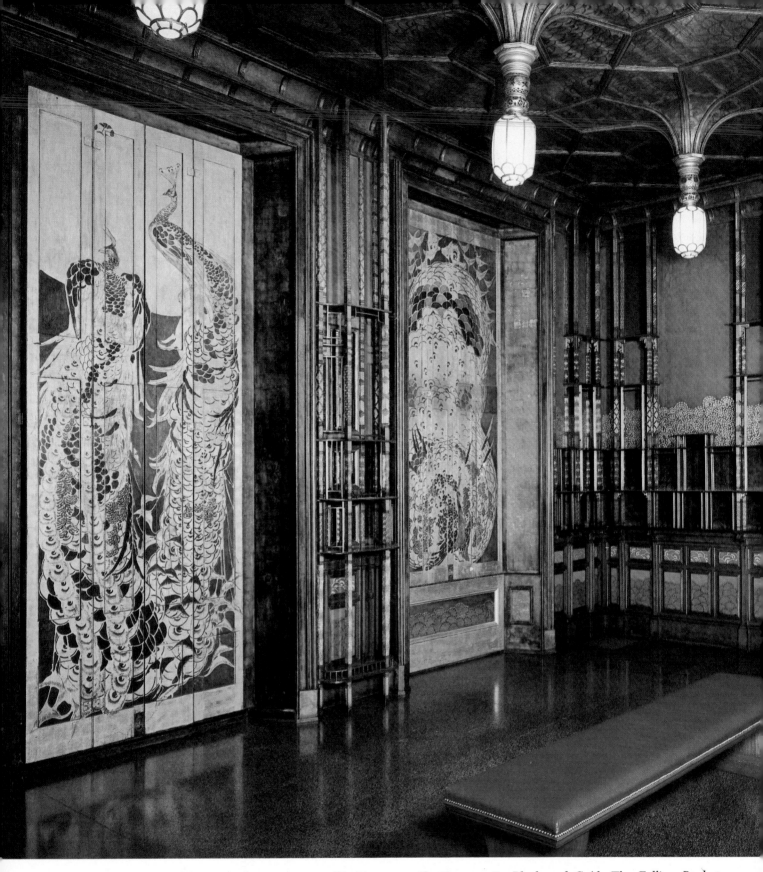

47. The Peacock Room, as it now appears. Washington, Freer Gallery of Art

48. *Nocturne in Black and Gold: The Falling Rocket*. About 1874. Panel, 60.4 × 46.6 cm. (23¾ × 18¾ in.) Detroit Institute of Arts

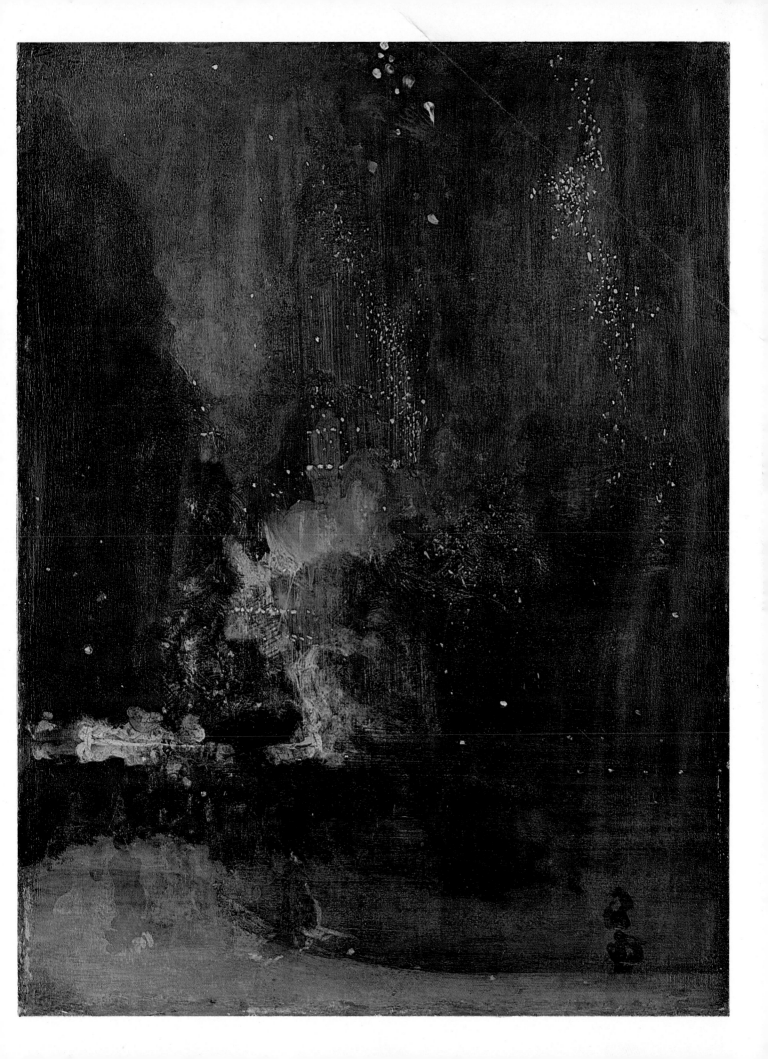

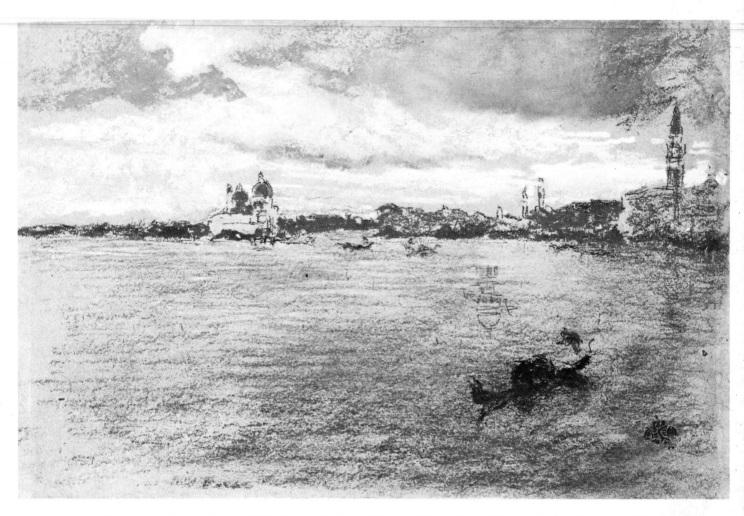

49. *Stormy Sunset*. About 1880. Pastel, 18.4 × 50.8 cm. (7½ × 20 in.) Harvard, The Fogg Art Museum

A trip to Venice provided the antidote to Whistler's dire condition. Plans to visit this city and produce a new set of etchings had previously been made in 1876, but had been postponed because of the Peacock Room. Now the Fine Art Society provided him with one hundred and fifty pounds for a three-month visit, in return for which they took the option on buying his plates and printing them in an edition of a hundred impressions on his return. He left for Venice early in September 1879 and was followed a month later by his recent mistress Maud Franklin, a slim red-head who had stayed with him throughout his worst days of poverty. He settled first at the Palazzo Rezzonico, moved to other lodgings and finally settled at the Casa Jankowitz, which housed a large party of American art students. At first he had difficulty settling down to work, but gradually his confidence returned. Before long he established for himself a central position in the English-speaking community and was observed at night in the Piazza San Marco 'praising France, abusing England, and thoroughly enjoying Italy'.

Whistler stayed not three but fourteen

months in Venice and during that time produced four oils, many etchings and almost one hundred pastels. Many of the latter are merely coloured drawings, charming but slight; they could not have taken more than a few hours to produce. In others (Plate 49) the pastel is boldly rubbed into position to suggest sunsets and other atmospheric effects. All were executed on brown paper (which he found in a Venetian warehouse) to give a warm background tone and sold well on his return to London. More remarkable are his etchings, in which he adopted an entirely new 'impressionistic' style. He used a lighter, more broken touch than in the 'Thames Set', well suited to the transient magic of Venice. Instead of taking the composition to the edges of the plate, he adopted a more allusive approach, often leaving areas incomplete or merely suggested. He employed a variety of techniques, mixing drypoint with etching and frequently leaving a slight film of ink on the

50. *Upright Venice*. About 1880. Etching and drypoint, 25.2 × 17.8 cm. (10 × 7 in.) University of Glasgow, Hunterian Art Gallery

51. *The Doorway, Venice*. About 1880 (reworked, 1889). Etching and drypoint, 29.5 × 20.3 cm. (11⅝ × 8 in.) Univ. Glasgow, Hunterian Art Gallery.

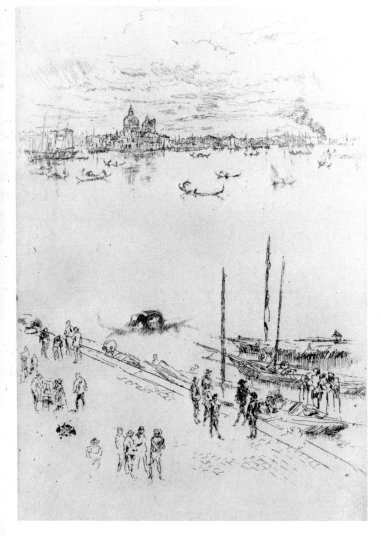

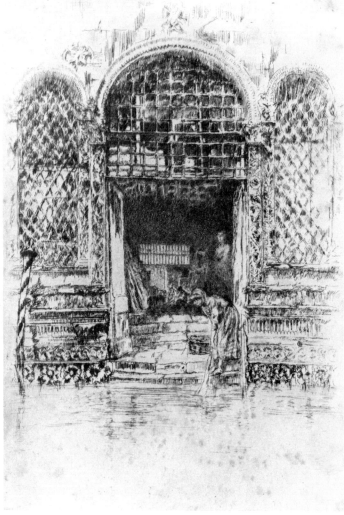

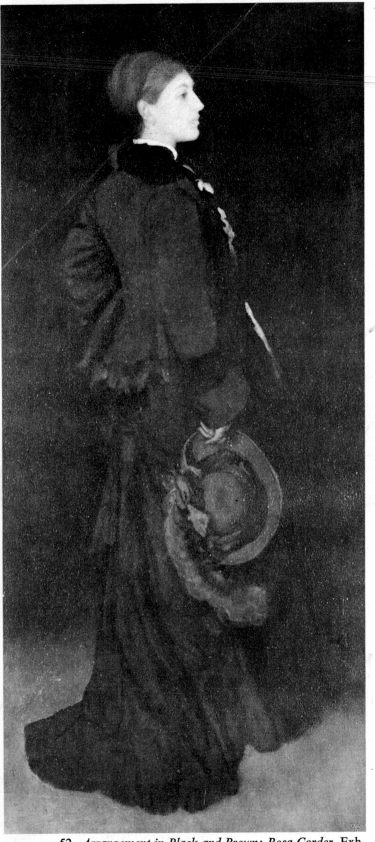

52. *Arrangement in Black and Brown: Rosa Corder.* Exh. 1879. Canvas, 190.8 × 89.8 cm. (75⅛ × 35¾ in.) N.Y., Frick Coll

plate to suggest water or to enrich the tone (Plate 51). Several of the plates were extensively reworked in London, growing richer and more elaborate with every new state.

When exhibited at the Fine Art Society in 1880, his first set of Venetian etchings was criticized for being unrepresentative of the city. Aware of an overwhelming precedence for the more popular views, Whistler deliberately investigated the poorer parts of Venice, the *calli* and narrow passage-ways inhabited by beggars and presenting sharp contrasts of light and shade. This series, therefore, reflects the return of his interest in genre subjects as well as his delight in the tapestry-like effect of Venice's crumbling walls and elegant façades. In 1883 the Fine Art Society put on an exhibition of his remaining Venetian etchings and underneath each entry in the catalogue Whistler reprinted the derogatory remarks made by the critics of his first set: 'Scampering caprice'; 'disastrous failures'; 'another crop of Mr. Whistler's little jokes'. The exquisite calligraphy of the etchings on view made the critics' comments seem pompous and blind: 'As we have hinted,' came from *The Times* critic, Harry Quilter, 'the series does not represent any Venice that we much care to remember; for who wants to remember the degradation of what was noble, the foulness of what has been fair?'

By the end of his stay in Venice, Whistler, confident that the work done would bring him success, was also anxious to return home. 'I am bored to death after a certain time away from Piccadilly,' he wrote to his sister-in-law, 'I pine for Pall Mall and I long for a hansom!' Accounts of his stay in Venice leave the impression of forced levity. He never let the art students among whom he lived forget his importance and developed an annoying habit of referring to himself in the third person: 'Whistler must get back into the world again.' His departure was witnessed with some relief.

Whistler's reappearance in London could not go unnoticed; he entered the Fine Art Society with a shoulder-high cane in one hand and a Pomeranian dog on the end of a long ribbon in the other. He looked at the prints on the wall (some probably by Seymour Haden, who was present) and said, 'Dear me! Dear me! Still the same sad old work!' He began moving in literary circles and for a while was closely associated with Oscar Wilde, the poet and publicist of the Aesthetic Movement, but became irritated by Wilde's dress and by his tendency to adopt the wit and ideas of others. 'What has Oscar in common with us artists,' he asked, 'except that he dines with us, and steals the plums from our plates to stuff the puddings that he goes and peddles in the provinces?'

Whistler had returned with the intent to conquer society and paint 'all the fashionables'. He wanted to give his sitters an impersonal elegance beyond style or fashion, but his reputation and fastidiousness meant that his sitters needed good health to endure the numerous sittings, and personal courage to withstand his wit. He established himself at 13 Tite Street and in his pale yellow dining room (which gave Howell the impression he was standing inside an egg) he held his Sunday breakfasts. Yellow flowers placed in blue vases made a harmony of blue and yellow and in the centre of the table goldfish swam in a large Japanese bowl. Stylish entertainment, however, attracted only a few sitters; his chief patronage in the eighties came from Americans and it was not until the following decade that he was in demand as a portrait painter.

The formula adopted for his full-length portraits had been established in the 1870s. *Rosa Corder* (Plate 52), portraying the mistress of Howell, is an example of the noble elegance and proud sense of individuality which Whistler attained in these portraits, un-

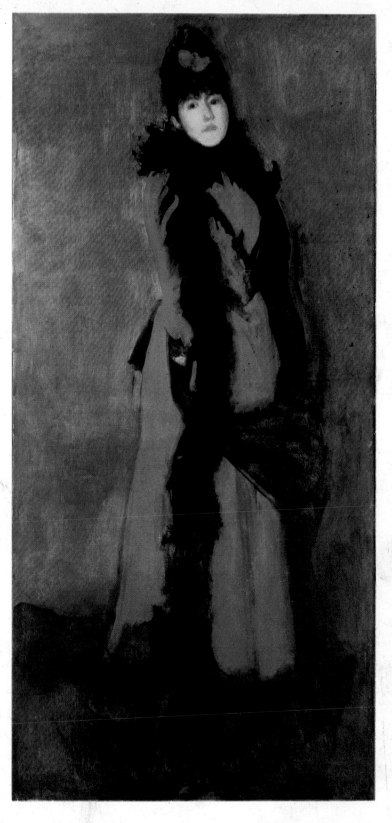

53. *Red and Black: The Fan: Mrs Charles Whibley.* About 1895. Canvas, 187 × 89.8 cm. (73⅝ × 35¾ in.) University of Glasgow, Hunterian Art Gallery

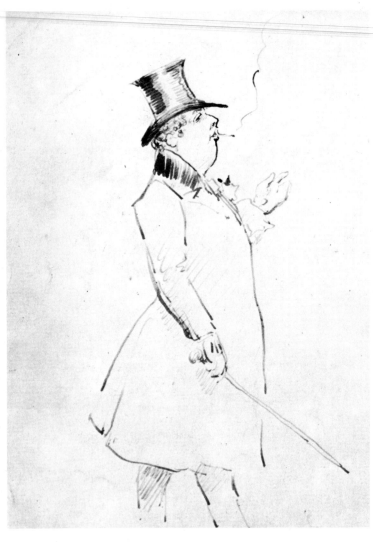

54. *Caricature of Oscar Wilde*. About 1885. Pen and ink,
University of Glasgow, Hunterian Art Gallery

to 'live within their frame and stand upon their legs', as Whistler said of Velasquez's portraits. It had also for Whistler a personal fascination. The Chicago lawyer, A. J. Eddy, observed that as the light began to fail, Whistler painted with ever-increasing urgency, 'until it seemed as if the falling of night was an inspiration'. Whistler himself explained why: 'As the light fades and the shadows deepen all petty and exacting details vanish, everything trivial disappears, and I see things as they are in great strong masses: the buttons are lost, but the garment remains; the garment is lost, but the sitter remains; the sitter is lost, but the shadow remains; the shadow is lost, but the picture remains. And *that* night cannot efface from the painter's imagination.'

In Whistler's hands, the genre of portrait painting became a major form of artistic expression. One of his most striking and effective portraits is that of Théodore Duret (Plate 58), an intelligent French aristocrat, journalist and friend of Manet and the Impressionists. On a visit to a London exhibition in the company of Duret, Whistler had noticed the incongruity in certain portraits of modern hairstyles with period clothing. Aware also of Baudelaire's praise of the heroism of modern life, he decided to portray Duret in modern evening dress. He made no preliminary drawings, but roughly indicated with chalk on the canvas the position of the feet and the head, and then began to paint. Duret posed over a period of several months, as each time Whistler decided to change a tone the entire canvas had to be rubbed down and repainted. The black of his suit is hardly modelled at all, but the incisive outline gives weight and body to the figure. The background is an indefinable neutral grey (which defies reproduction), but because of its sympathy with the warm tones in the sitter's face, the red of his fan and subtle pink of the opera cloak over his arm, it takes on a warm tinge.

cluttered by any of the standard accoutrements used to suggest the sitter's background or profession. The idea for the portrait came to Whistler when he observed Rosa Corder pass in a brown dress in front of a dark doorway. In his choice of lighting, Whistler favoured a low, quiet light, similar to that in which Holbein placed his sitters, under which the flesh tones remain dim and in harmony with the rest of the colours. The dusky, atmospheric background enabled his subjects

Whistler delighted in holding a piece of white paper with a hole at its centre over the background to prove that, when isolated from the rest of the composition, it was a pure, cool grey.

Portraits apart, Whistler was much occupied in the 1880s with watercolour (Plate 62), and with small oil panels of seascapes (painted at Dieppe, Dover, St Ives and Trouville) and of shopfronts. The charm of the latter lies in the locking together of tone and hue across the

55. *Design for a Velarium.* 1886. 25.7 × 17.7 cm. (10⅛ × 7 in.) University of Glasgow, Hunterian Art Gallery

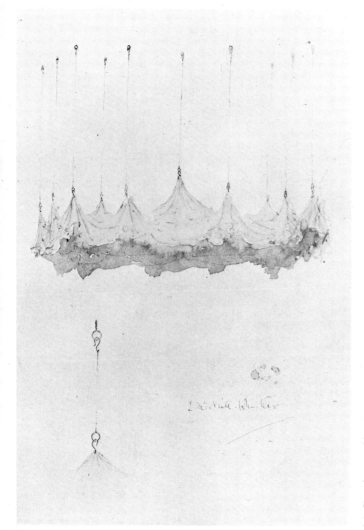

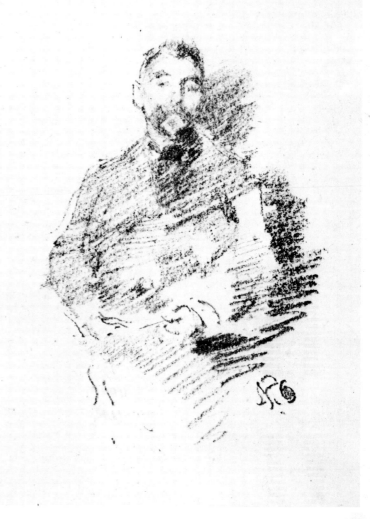

56. *Stéphane Mallarmé.* 1892. 9.6 × 7 cm. (3¾ × 2¾ in.) Washington, Freer Gallery of Art

geometric structure of the façades. As the decade progressed they became looser in execution and more impressionistic, the grey base, on which many are painted, frequently playing an active part in the composition. Many of these small panels were painted in the company of two new followers, Walter Sickert (Plate 66) and Mortimer Menpes, who prepared the 'Master's' panels and accompanied him on his wanderings. In his *Ten o'Clock Lecture* delivered in 1885, Whistler

67

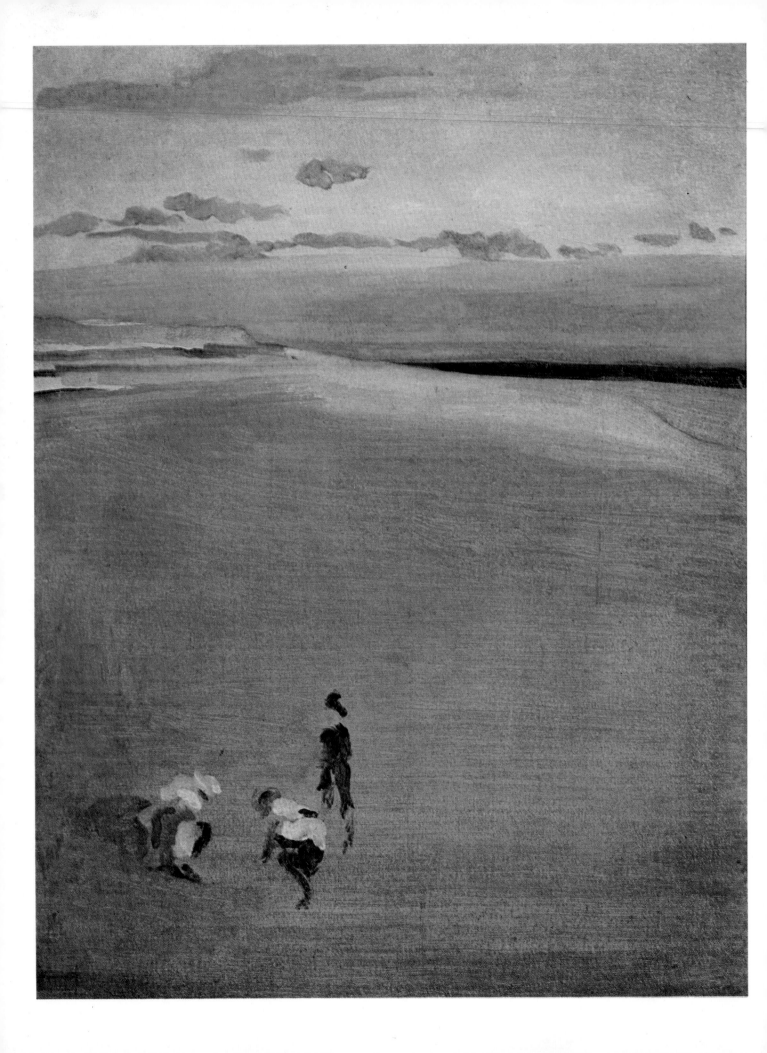

defined the aims of art as 'seeking and finding the beautiful in all conditions and in all times'. In Chelsea, his eye was attracted to small incidents, such as Mortimer Menpes described: 'It might be a fish shop with eels for sale at so much a plate, and a few soiled children in the foreground; or perhaps a sweetshop, and the children standing with their faces glued to the pane' (Plate 67).

After two successful one-man exhibitions at Dowdeswells in 1884 and 1886, Whistler's reputation steadily began to mount. In 1884 he had the honour of being invited to become a member of the Society of British Artists and two years later was elected its president. It was an old-established society but in recent years its reputation had sunk and it was badly in need of someone with Whistler's flair for publicity to re-establish its position. He put his professionalism into practice as soon as he was elected president: the society's notepaper and signboard were redesigned; he insisted on a harsh jury, careful decoration of the gallery, and hung the paintings with ample space between each; he designed a velarium (Plate 55), which hung from the ceiling and subdued the overhead lighting to a more sympathetic level. Selectivity, however, did not make for increased sales and gradually criticism began to be heard. 'I wanted to make the British Artists an art centre,' Whistler declared; 'they wanted to remain a shop.' In April 1888 he was asked to resign. Several of his followers left with him, causing him to remark, 'the Artists have come out, and the British remain.' After his death *The Times* pointed out that the decision to make Whistler president 'was like electing a sparrow-hawk to rule a community of bats'.

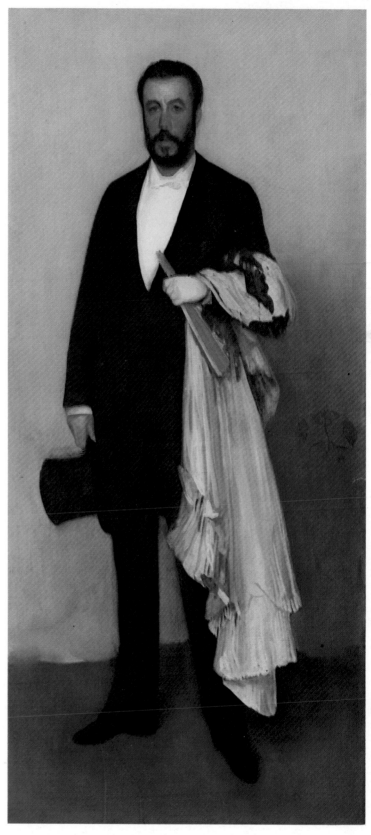

57. *The Beach at Selsey Bill*. About 1875–80. Canvas, 61 × 47.5 cm. (24 × 18¾ in.) Connecticut, New Britain Museum of American Art

58. *Arrangement in Flesh Colour and Black: Portrait of Théodore Duret*. 1883. Canvas, 193.3 × 90.8 cm. (76⅛ × 35¾ in.) New York, The Metropolitan Museum of Art

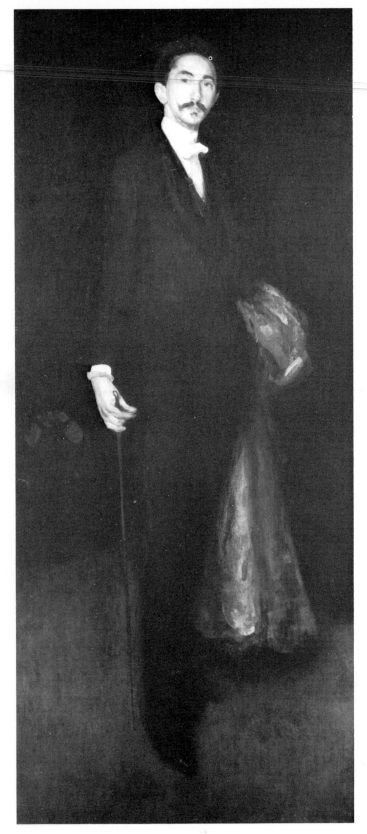

59. *Robert, Comte de Montesquiou-Fezensac*. 1891.
Canvas, 205.7 × 88.8 cm. (79 × 34⅞ in.) New York,
The Frick Collection

60. *Harmony in Red—Lamplight—Mrs Beatrix Godwin*. 1886.
Canvas, 189.8 × 88.9 cm. (74¾ × 35 in.) University of
Glasgow, Hunterian Art Gallery

70

In 1885 Whistler moved into a studio in Fulham Road and there painted *Harmony in Red: Lamplight—Mrs Beatrix Godwin* (Plate 60). Arms akimbo, the sitter appears as if caught in conversation with the artist. Her husband died in 1886 and two years later she became Whistler's wife. Plump, pretty, cheerful and a thorough Bohemian, she prepared for her second marriage simply by buying a new toothbrush and sponge. The daughter of the sculptor John Bernie Philip, she was also an artist in her own right and Whistler frequently turned to her for advice while painting his portraits. He regarded her not only as his marital partner, but as his companion-fighter in his battle with art, and would preface discussion of his progress in his letters with the term 'we'.

With Beatrix, Whistler moved to Paris in 1892, taking an apartment in the Rue du Bac. He believed that the whole house should be a harmony of which the picture or print is only a part and spent as much care over its decoration as he had previously done on galleries for his one-man exhibitions. The reception room had blue and white panelled walls which harmonized with two blue paintings by Whistler and the stuffs that covered the few pieces of elegant furniture. From a Japanese bird-cage hung trailing arrangements of flowers which ended in blue and white bowls and little tongue-shaped dishes.

One important portrait executed at this time was that of Comte Robert de Montesquiou-Fezensac (Plate 59), the poet and elegant figure on whom Huysmans modelled des Esseintes and Proust, in part, his Baron de Charlus. As a sitter he was immensely sympathetic to Whistler for a number of reasons: an intelligent dandy with impeccable taste, he too believed that 'there is nothing beautiful, grand or sweet in life that is not mysterious'. He had that etiolated distinction that characterizes aristocracy on

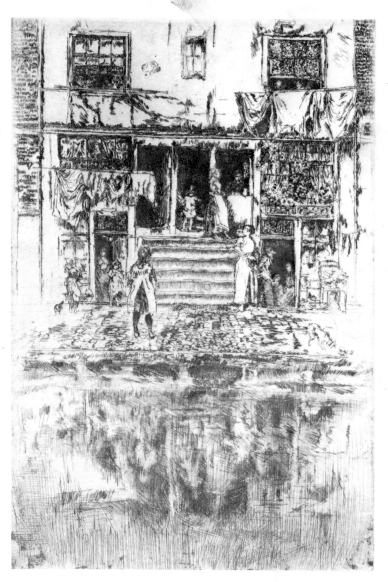

61. *Steps, Amsterdam*. 1889. Etching and drypoint, 24.1 × 16.5 cm. (9½ × 6½ in.) Washington, National Gallery of Art

the verge of disappearance and Whistler searched for an element of dash and finesse to express his personality. Like Duret, Montesquiou is in evening dress and carries an article of clothing (here a chinchilla greatcoat) to prevent the figure from tapering away in the lower half. To give it immediacy and breadth, Whistler finished the portrait with one final, complete coating and then had the pleasure of observing the count's childlike joy in the statement of pride the picture represents. 'I dare scarcely believe',

Whistler wrote to his wife, 'that the picture can be as superb as in the gloaming it looked. You know how the poor grinder is lonely and tired in the morning—and how he lives in terror of the first peep at his painting before breakfast . . . and certainly in the fluttering light of the evening our Montesquiou *poète et grand seigneur* did look stupendous!'

Another literary friendship that Whistler enjoyed in Paris was with Mallarmé, the poet who regarded words as objects in their own right (as Whistler did forms and colours), yet allowed a plurality of allusions to gather to them. Whistler's 'Nocturnes' achieve their effect by omission; Mallarmé advised: 'To name an object is to suppress three-quarters of the pleasure . . . to suggest, there is the dream.' The two men were formally introduced by the Impressionist Monet in 1888 and soon after Mallarmé translated Whistler's *Ten o'Clock Lecture*. They carried on a lengthy correspondence and when in Paris Whistler would attend Mallarmé's celebrated *Mardis*. For the frontispiece to his *Vers et Prose* published in 1893, Whistler executed a lithograph portrait of the poet, which, though apparently improvisatory, took several rejected efforts before it reached the allusive

62. *Nocturne, Grand Canal Amsterdam*. About 1884. Watercolour on paper, 22.7 × 28.4cm. (8⅞ × 11⅛ in.) Washington, Freer Gallery of Art

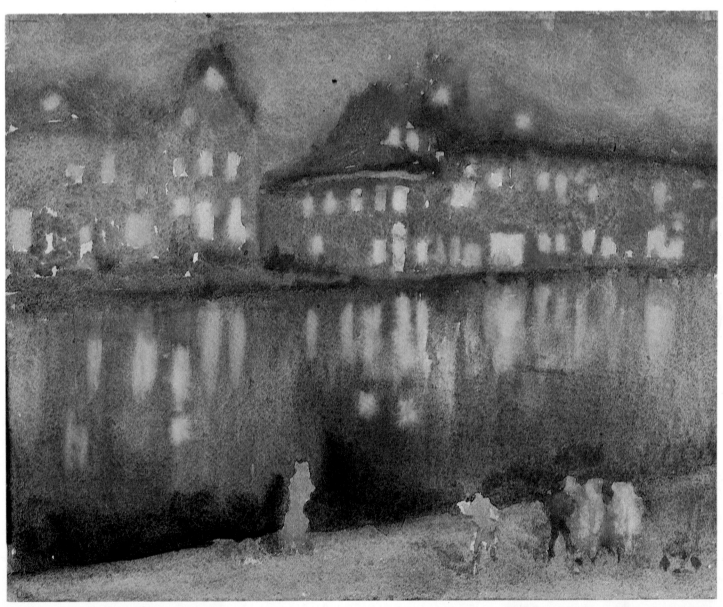

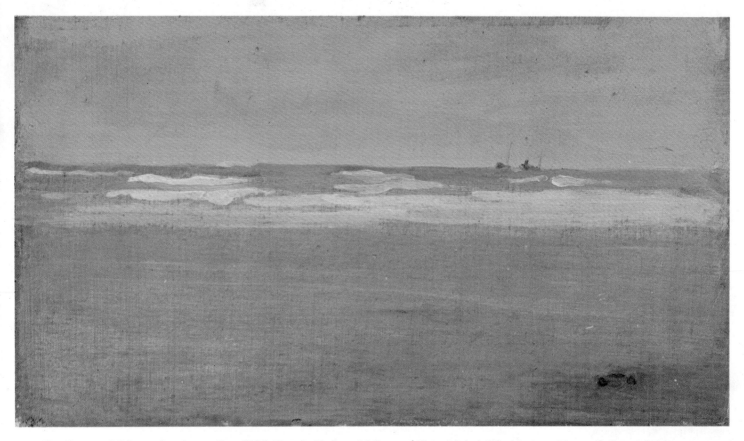

63. *Grey and Silver: the Angry Sea*. 1884. Panel, 12.4 × 21.7 cm. (4⅞ × 8½ in.) Washington, Freer Gallery of Art
'He will give you in a space nine inches by four an angry sea, piled up, and running in, as no painter ever did before.' (Walter Sickert)

result, which hints, like Mallarmé's poems, at the whole (Plate 56).

Lithography was the medium which in the 1890s took over from etching in Whistler's career. Although in 1889 he had produced a set of etchings on Amsterdam (Plate 61), in which he observed with satisfaction that he had combined the 'impressionism' of his Venice etchings with the minuteness of detail found in the 'Thames Set', he turned to lithography because of its greater directness. 'Lithography *reveals* the artist in his true strength as draughtsman *and* colourist,' he wrote, 'for the line comes *straight from his pencil* and the tone *has no further fullness* than he himself, in his knowledge, gave it.' He could, in this medium, record the façade of a building with a handful of marks, leaving the eye, as in Cézanne's late watercolours, to span the gaps imaginatively. Several of the lithographs are of fashionable women, concerned with catching the tilt of a hat, an elegant pose or the outline of a modish dress.

Whistler's late years saw no radical change of direction or introduction of new matter into his art. He did, however, undergo an artistic crisis while staying at Lyme Regis in 1895 when his old uncertainty about the value of his work returned. He learnt that his former desire to achieve the final result in one effortless *coup* was misleading and that, as he informed his wife, 'time *is* an element in the making of pictures! and *haste* is their undoing'. *The Master Smith of Lyme Regis* (Plate 64) is perhaps one of the paintings in which Whistler felt he emerged from his crisis in triumph. Built up out of overlapping layers of paint, it has an engaging sense of reality, similar to that found in his portraits of children produced at this time, which are

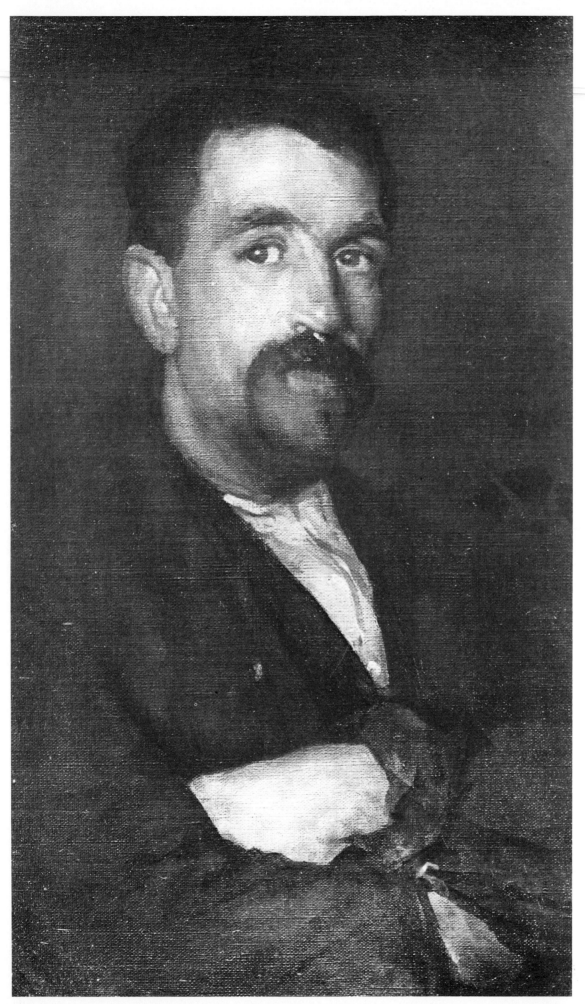

64. (left) *The Master Smith of Lyme Regis*. 1895. Canvas, 50.8 × 31.1 cm. (20 × 12¼ in.) Boston, Museum of Fine Arts

65. (right) Sheet of Studies of Loie Fuller Dancing. 1893–4. Pen and ink, 21 × 32 cm. (8¾ × 12⅝ in.) University of Glasgow, Hunterian Art Gallery Loie Fuller's skirt act was the sensation of the Parisian season 1893–4. With the aid of coloured spotlights, she would create linear arabesques and patterns of movement by the whirl of her skirts (her actual dancing was thought to be fairly mediocre). One dance she performed was entitled 'butterfly', into which Whistler transforms her in these quick sketches.

notable for their tenderness and pathos yet entirely devoid of sentimentality.

Meanwhile Whistler's reputation had soared. In 1891 *The Artist's Mother* was acquired by the French State and that same year Glasgow Corporation paid a thousand guineas for the *Carlyle*. Having exhibited at several important international exhibitions, Whistler was now awarded honours by Munich, Amsterdam and Paris. In London he was invited to exhibit at the New English Art Club and in Scotland was revered by the Glasgow School as the greatest living artist. In 1892 his one-man show at the Goupil Gallery caused the final turnabout in public feeling towards him and after this success the Duke of Marlborough commissioned his own portrait, but died before Whistler had time to begin work on it, and only a pen and ink sketch remains (University of Glasgow). A little bitter that commissions were only now coming in, Whistler declared, 'If I had had—say, three thousand pounds a year, what beautiful things I would have done.'

Since the Ruskin trial, Whistler's love of polemic had engaged him in frequent warfare in the press and in the law courts. As a controversialist, he is celebrated by his *The Gentle Art of Making Enemies*, a collection of his writings published in 1890 with the dedication, 'To the rare Few, who, early in Life, have rid Themselves of the Friendship of the Many, these pathetic Papers are inscribed.' As well as reprinting offensive articles by art critics and his sardonic sallies in reply, the book contains his *Ten o'Clock Lecture*

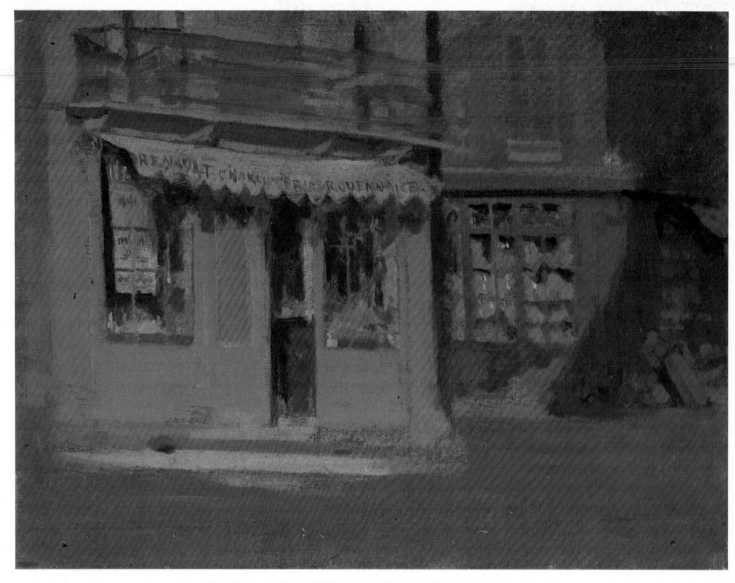

66. Walter Sickert (1860–1942): *The Red Shop* or *The October Sun*.
About 1888. Panel, 26.7 × 35.6 cm. (10½ × 14 in.) Norwich Castle Museum (Norfolk Museums Service)

and his 'Propositions' explaining his methods, and thus represents not only his wit but also his artistic philosophy. As with all his publications, the carefully considered typography and design were strikingly uncluttered by comparison with standard practice of the day.

Whistler's desire to teach and preach found further outlet at the Académie Carmen in Paris, opened in 1898 by one of his models, Madame Carmen Rossi, and originally advertised as the Académie Whistler. Whistler agreed to act as visiting teacher, intending to

offer the students his knowledge of a lifetime. He taught that art was a science, one step leading to another, and advised 'Distrust everything you have done without understanding it.' After a year or two his visits became infrequent and in 1901 the school closed. Several of his pupils found his deep distrust of superficial effects disencouraging, but the school is distinguished by one pupil alone, Gwen John (Plate 69), who developed a system of numbering her colour mixes in imitation of Whistler's scientific approach

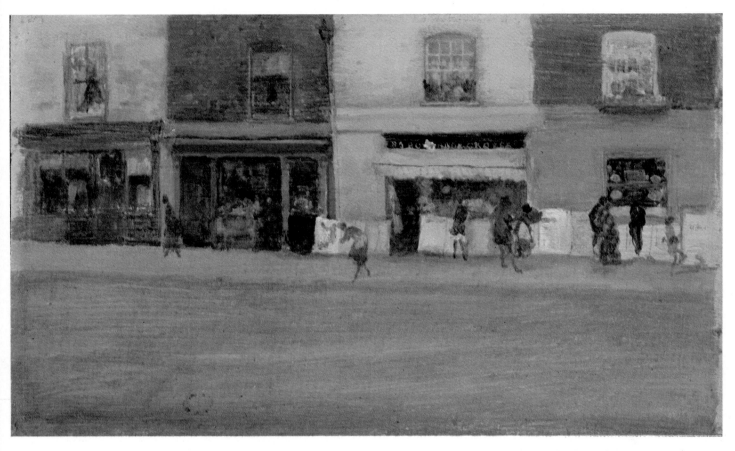

67. *Chelsea Shops*. Early 1880s. Panel, 13.5 × 23.4 cm. (5¼ × 9¼ in.) Washington, Freer Gallery of Art

and who was praised by her master to her better-known brother for her 'fine sense of tone'.

Since late 1894 Whistler had known that his wife was fatally ill with cancer. On a visit to London early in 1896 the couple put up at the Savoy Hotel, where Whistler executed lithographs of his wife, calling one *The Siesta* (Plate 68), as if to convince himself that she was not dying, but only resting. From the hotel window he executed eight views of London which lack the easy notation of form found in his lithographs of Paris and suggest that they were drawn under stress. In the spring of 1896 he moved his wife to St Jude's Cottage, Hampstead, where in May she died. On the morning of her death Whistler was seen walking by a friend and could only say, 'Don't speak! Don't speak! It is terrible!'

After the death of his wife, Whistler became increasingly dependent on her mother and sister—the 'Ladies', as he referred to them. In May 1900 he asked Elizabeth and Joseph Pennell to undertake to write his life and

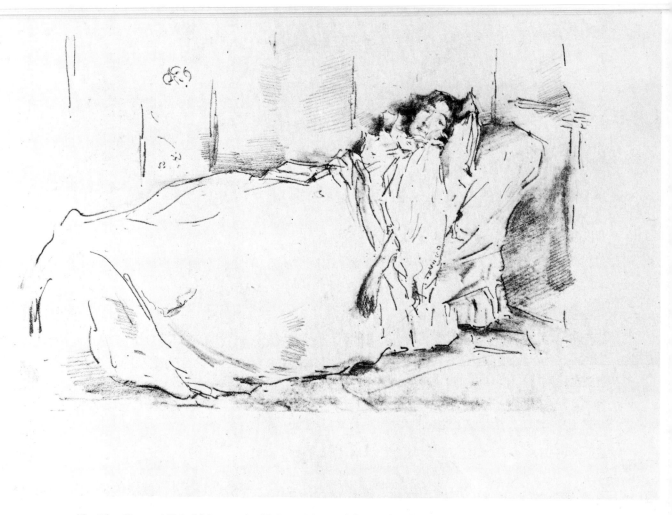

68. *The Siesta*. 1896. Lithograph, 13.7 × 21 cm. (5⅜ × 8¼ in.) London, British Museum

spent much time during these last three years in their company, reminiscing and expounding his ideas on art. He continued to make frequent trips abroad, to Pourville, Paris, Tangier, Corsica and Ireland, and to produce small oils, such as that of his sister-in-law (Plate 70). This was one of several small full-lengths produced at this time to prove the fallacy of the statement that the effect of a portrait depended on its size. The intimate note struck has much in common with the bourgeois interiors of Bonnard and Vuillard, whose lithographs Whistler admired and

owned. Ill-health gradually weakened his powers and during the last year of his life he was largely confined to the house he was then living in, 74 Cheyne Walk, where he shuffled round the studio in a shabby fur-lined coat.

The deliberate limitation of subject-matter in Whistler's *oeuvre* enabled him to concentrate more fully on the gradual refinement of his formal means and on the use of radically simplified design that presages the twentieth-century concern with abstraction. He was the most intransigent, independent thinker in the English art world at a time when it was

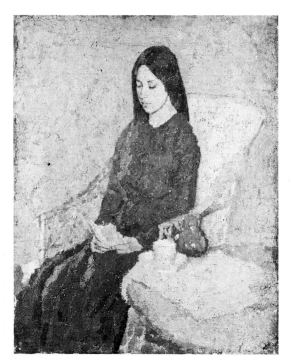

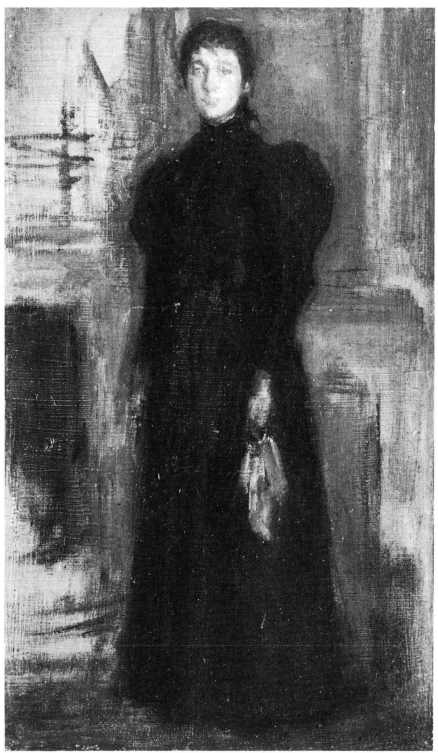

69. Gwen John (1876–1939): *The Conva-lescent*. Early 1920s. Canvas, 40.9 × 33 cm. (16⅛ × 13 in.) Cambridge, Fitzwilliam Museum

70. *Mrs Rosalind Birnie Philip Standing*. About 1897. Oil on wood, 23.5 × 13.9 cm. (9¼ × 5½ in.) University of Glasgow, Hunterian Art Gallery

79

notoriously insular. Concerned with creating art and not commercial artefacts, he presided over the International Society of Sculptors, Painters and Gravers from 1898 until his death with the same professionalism that he exercised on the Society of British Artists: careful selection, decoration and hanging governed the exhibitions, and members were forbidden to belong to any other society. Yet emphasis on quality led him to underplay the emotional and intellectual content in art; his portraits, while asserting individuality, remain strangely impersonal. His art can be criticized for being too tasteful, too much a matter of nerves, too concerned with aesthetics, 'a plant without roots and bearing no fruit,' as Sickert wrote in 1912. Often the subject is slight, but seizing on the thing seen, Whistler then made of an arbitrary pose stilled in mid-action, of a transient effect of light, something ordered and permanent, thereby brushing with eternity a moment in time.

71. Design for Butterfly. Around 1898.
Pen and ink, 17.3 × 11.3 cm. (6¾ × 4½ in.) University of Glasgow, Hunterian Art Gallery